artists

artists

photographs by **gautier deblonde**

with an essay by **mel gooding**

Tate Gallery Publishing

ISBN 1 85437 291 2

A catalogue record for this book is available from the British Library

Published in 1999 by order of the Trustees of the Tate Gallery

by Tate Gallery Publishing Limited, Millbank, London SW1P 4RG

Photographs © Gautier Deblonde 1999

Essay © Mel Gooding 1999

Gautier Deblonde and Mel Gooding have asserted their moral rights

Designed by Richard Krzyzak

Printed in Italy by Arti Grafiche Amilcare Pizzi, Milan

Cover photograph of Cornelia Parker

A mes parents

images for a book

Photography today is more than a science: it has risen to the level of art.

NADAR

I AM CONTEMPLATING TWO PHOTOGRAPHS of his friend Charles Baudelaire taken by Nadar in the mid-1850s. In the first, the poet, now in his mid-thirties, is standing at an angle to the camera, left hand in his trouser pocket, the silk lining of his closely fitted jacket exposed, round his neck a large bow-tied cravat. He looks sideways, directly into the lens, eyes intense, lips pursed, the light catching the left side of his face and forehead, from which his hair is swept back. The image is slightly out of focus, and seems over-exposed, the illuminated half-face starkly white, the featureless space in which he stands going into darkness in front of him. Baudelaire liked this portrait enough to have owned it. Perhaps it was the almost fleeting, apparition-like immateriality of the image that appealed: the intensely self-aware dandy-poet caught between light and dark. The other photograph, again both imperfectly focused and exposed, pictures him leaning backwards into an armchair, with his high forehead catching the light, which comes this time from the left of the picture, illuminating his hands against the undifferentiated darkness of his coat, the left raised to his cheek, the right resting on white gloves on his lap. His raised collar and right arm create a dark diagonal silhouette from upper right to lower left. His expression is dreamy, as if thought had deserted

him, but the slight angle of his head to the diagonal division of darkness and light destroys any sense of repose, and the blurring of the image around his face creates a mysterious vagueness out of which the poet seems to be emerging like a ghost.

THERE ARE OTHER, more famous, photographic images of Baudelaire, including others by Nadar himself, who was a close friend and admirer, but none that match these in intensity, that catch for the viewer the febrile unease that was so distinct an element in the personality of the great poet. Though the rich and famous – *le tout Paris* – clamoured through his portrait studio at 113 rue Saint-Lazare during its golden years in the late 1850s, and paid handsomely for the privilege, Nadar approached his work with artists and writers, the circle of his true friends, as a creative rather than a commercial enterprise. It may be that the technical imperfections of these Baudelaire images are precisely what give them their special potency, a poetic energy that seems to emanate from the sitter himself, and which distinguishes them from the conventionally posed formal photographic portraits so fashionable at the time. 'Although the universal principle is one, Nature presents us with nothing absolute, nothing even complete' Baudelaire had written in 1846; 'I see only individuals.' Praising the portraiture of Ingres he remarked that he was not 'one of those painters-by-the-hour ... to which the common lout can go, purse in hand, to demand the reproduction of his unseemly person', but that he *'chooses* his models', bringing 'a wonderful discernment to his choice of those that are best suited to exploit his special kind of talent'. Nadar's photographs of his artist and writer friends exemplify the virtues implicit in Baudelaire's words: they are of remarkable individuals, whose character or personality might be revealed to the camera in sessions distinguished from everyday commercial sittings by their pleasurable informality, a kind of intimacy or complicity; they were not commissioned but done out of a passion at once intellectual and emotional; and they have the quality of the best kind of portrait, being *'a model complicated by an artist'*. They are, that is to say, expressive both of the artist behind the camera and of the artist in front of it.

THERE ARE PHOTOGRAPHERS – Kertesz, Cartier-Bresson, Brassaï, Brandt come immediately to mind – who have brought to the portraiture of artists something comparable to this kind of concentration with its attendant

revelation, who have been in the way that Nadar was, artists in their own right. There have been, on the other hand, any number of photographers who have been fascinated by artists, or who have exploited the curiosity of the public in the lives of artists, and the demand that has existed since Nadar's day for photographs of them. Gautier Deblonde belongs in the former company. His work possesses those qualities that makes the best photographs of artists so memorable: they are the outcome of a kind of creative collaboration. This requires specific definition. It does not, in the first instance, derive in every case from close friendship, or even acquaintance, but in most cases it does recognise the unusual nature of the exchange between the photographer and 'the model'. These photographs of Deblonde's have no documentary intention (though he is a most accomplished documentary cameraman, when commissioned to be such), and neither are they 'portraits of the artist' whose purposes might be usefully promotional, which purport to reveal the 'character' of the 'person behind the work', or, taken in the artist's studio, provide 'insight' into the creative impulse itself. Deblonde's methods deny control to the subject, refuse to allow the subject's management of the photographic image, are not employed to project the image of the artist in the other, wider, sense of the term. He is after an image, to be sure, but it is one that is expressive on its own terms, and like any true artist he cannot predict exactly what it will be. To be photographed in this way is to accept certain conditions of engagement, to cede control. It is to accede to the creative purposes of another artist.

IN PUTTING IT THIS WAY we come close to the heart of the matter. For what makes these photographs so extraordinary is the quality of the engagement of their subjects with the process. Who better than artists to know what creative purposes are like? What is the distinction between creative and other kinds of purpose? It is this: that the creative purpose is its own end, and works through the creative being to make a work. Artists are the instruments of these purposes, the means to creative ends. The greatest photographs of artists are those in which the subject, recognising the artistic integrity and creative otherness of the photographer, connives in a joint enterprise to serve creative purposes. These purposes may, of course, differ, and they may include those of serving the art of the artist-subject even as they serve the expressive purposes of the artist-photographer. Consider some famous examples, drawn from the work of those mentioned above: Kertesz's photograph of Mondrian's Paris apartment, which constitutes the

most telling portrait of the invisible painter, a wonderful resemblance; Cartier-Bresson's poignant studies of Bonnard at Le Cannet, in which the photographer is allowed, momentarily, to share the loneliness and sadness of the painter's last years without Marthe; certain of Brassaï's portraits of Picasso, which elaborate a myth in which he fully believes, yet hint at the vanity of genius; Brandt's catching, in lurid lamplight on Primrose Hill, a demonic Francis Bacon. In each case there is the precondition of collusion, a relation quite different to that of the documentary photographer or professional portraitist with his or her subject. With the exception of the Kertesz, whose true subject has made of himself an eloquent absence, the artists in these great photographs each indicates, as does Baudelaire in the Nadar portraits, by a look, a gesture, a physical disposition, that he is aware of the camera, is *at work* with the photographer.

WHAT IS AT STAKE here is something other than a likeness, 'the exact reproduction of Nature' scorned by Baudelaire in his satirical attack on portrait photography. What is found in those celebrated images is a poetic truth, over and above the representation of a situation, the recording of a moment. As with any other poetic image, there arises the question of meaning. That is something created by the viewer, not necessarily in words, though the works must make their way within a discourse. What distinguishes these images of Deblonde's from those of the photographic diarist of the 'art world', the formal portraitist, or the documentary observer of the 'artist in the studio', lies precisely in the discursive field within which they operate upon the receiving sensibility. It is the field of art itself. That the images are of artists is, essentially, incidental. It is not, however, at all unimportant; indeed the information that the images *carry,* their import, is central to their interest and power. The subject matter of art, what it pictures (or not) is central to its creative purpose. And this makes the example of Nadar with which we began (and with which photography as an art, consciously professed begins, with, as it happens, a precisely analogous subject matter,) so apposite. Defending his pseudonym (and his reputation) against its misappropriation by his less-talented brother, he declared that photography was both a scientific process (with, by implication, many possible uses in any number of discourses, scientific, topographical, sociological, journalistic etc.) and an art requiring special gifts for its successful practice: 'What can be learned still less [than 'the sense of light … the different and combined qualities of light'] is the moral intelligence of your subject … [or] the swift tact that puts you in communion with the model … and allows

you to render … the resemblance that is most familiar and most favourable, the intimate resemblance … What also can't be learnt is integrity of work; in a genre as delicate as portraiture, it is zeal, the search, an indefatigable perseverance in the relentless pursuit of the *best.*'

TO THE ARTISTS with whom he has worked to create images for this book, Deblonde is well known for his persistence, his 'indefatigable perseverance' in pursuit of the image. For the 'best' means to him, as to his great predecessor, the image that goes beyond 'commonplace and accidental' likeness, or that pretends to the revelation of the inner person, when its actual purpose is to invent or construct a character or personality appropriate to the self-image of the subject or to the image the public might think proper to the subject's calling. (There is no consensus to these public perceptions.) To get the image that meets his demand for truth, his truth, may entail many occasions of working with the artist (Deblonde always speaks of 'working with'), of visits and re-visits; and after all, scanning the frames on many contact sheets, there may remain frustration that the resemblance is uncaught, the best has eluded the camera, the quality so desired is unachieved. In other cases the sought-for occurs immediately: out of the darkroom solution there precipitates a marvellous image from a single encounter. What Deblonde seeks is hard to define in words. Talking with him about the project over several years I have not learnt from him what it is. What Deblonde *finds,* on the other hand, is evident: it is something unexpected, unplanned, unpremeditated; it is a discovery determined by his method; it is an event you couldn't anticipate.

IT IS AN IMAGINATIVE event created out of an encounter with an artist. That is what is special about these photographic events, and creates a sequence, or concatenation, of images. To suggest that they belong as works of imagination within the realm of aesthetic discourse is to be obliged to define the discursive space within which they are intended to make their way into the viewer's imagination. It is the space of the book, specifically the photographic monograph, and this places them within a discernible artistic tradition, of which Deblonde is keenly aware. The disposition of images in any book will have a logic that serves a purpose; in the present case it is random, and the viewer may look at these images in any order, start anywhere, close the book anywhere. There is indeed a purpose

here: the book reflects the world it pictures, and refuses to categorise in the different ways characteristic of other discursive spaces, those, for example, of the exhibition, the art history, the journalistic survey. It makes no distinction in its ordering between the potential and the established, the famous and the little known, the glamorous and the unglamorous, and the young, the middle aged and the old, those who are of a particular tendency or movement, or the focus of a publicity phenomenon. It makes no claim to be comprehensive, to establish a pantheon. There are artists who might have been here, but that the contact sheets failed to yield the image desired; there are some artists who, denying the encounter, refused to be here; there are others, who failed to return telephone calls, or were away, or could not find time. In such fortuitous inclusions and exclusions also the book is like the world from which it comes.

WE ARE ACCUSTOMED to call this 'the art world'. And it is a world of which we heard a great deal in the mid-1990s, the period in which these photographs were taken, and which will give them their particular feel and atmosphere as time goes by. But, in truth, there has never been one 'art world', the more so now when there has been a quantitative leap in the number of practising artists, an explosion of artistic activity, an unprecedented increase in public interest in art. Rather it is a lot of little worlds, some of which run into others, some posh, some glamorous, some down-at-heel, some more or less inhabited by the young, some institutional, some academic, some sedately bourgeois. The last time it seemed possible to chart the most interesting enclaves of this diverse territory with confidence was in the 1960s, when Bryan Robertson, John Russell and Lord Snowdon published *Private View,* which claimed to 'identify' the 'specific society' within which, and for which, works of art were made in 'one of the world's three capitals of art'. It was a society, Robertson and Russell asserted, with truth, that could 'only be known and presented, as we do here, from the inside'. I doubt if the task could be approached with such cartographic confidence in 1999. Now we have partial views, partial mappings: post-modern diaristic meanderings, photo-reportage, promotional catalogues, and 'users' guides'. The most comprehensive of the latter, Louisa Buck's *Moving Targets,* claims no more than to be highly selective, 'an indication rather than a representation of what is taking place at the moment'. The London art world of *Private View* was a place to explore; the British art world of the mid-1990s was a time to be had.

IT WAS QUITE A TIME. And if much that was written about it in the broadsheet newspapers and the magazines was nonsense, there was a lot of diverse and unpredictable art being made, and not only in London. There was also *attitude*: art was important, art was crucial, but it didn't need to be po-faced, pompous or self-righteous. It could deal with the here-and-now, it could remake the world as beautiful or ugly; it could take many forms; whatever you made, or did, might qualify. After a decade of critical and commercial success for painting and object sculpture, those media were called into question once again, as they had been in the so-called 'conceptual seventies': who was art for? what was art for? The art of the 1990s, we are told, was gestural and conceptual; it could be cool, and ironically self-reflexive, or messy and personal; it could play games with categories, with the meanings of words and things, and with the systems by which things are classified. It could be non-referential, or irresolutely·political. It was best if it was witty, disingenuous, hinting at the impossibility of knowing the true nature of things (whatever that may be). That kind of ironic distance is what passed for reality in the murky later years of Conservative rule. There was an elegiac irony in the air; a sense of lost innocence, lost beauty (the word itself was lost to use: what did it mean?), lost optimism, lost confidence. The bright young British artists so much in demand for their season, were not so much the Children of Albion, claiming their inheritance in days of hope, as the witnesses of social disinheritance and cultural disintegration. That much of their best art reflected this with a hurt sad rigour seemed to have been lost in most of the excited commentary.

IF I DETECT A LEIT-MOTIF in this succession of photographic images it is this, a kind of melancholia; and this may be a truth about the artist in the mid 1990s that Deblonde, the outsider-insider, coming from elsewhere, has discovered. It is not the only truth revealed here. For there are other energies in British art, and they are to be found in the work of artists of all generations, working in all sorts of ways in all sorts of places. Much of it carries forward the diverse projects of painting, sculpture, performance, printmaking, installation, photography, film and video in modes and means determined in all the decades of modernist experiment and consolidation, or in the years of post-modern reaction and reformulation. Deblonde, close as he in age is to the younger artists with whom he has worked in London, has taken the necessary journeys to other places, other worlds. Wherever he goes, what makes his work

distinctive is the intensity of its attention to its subject, the quality of its 'complication of the model'. It is an intuitive collusion with the human reality of the artist, a provoking of the event that will make the image. He says: 'The work is a series of discoveries, infiltrations of private worlds and intimate spaces.' The work is the book, a procession of momentary events, of facts not fictions. I mean, the photographs are the facts. Deblonde knows that the camera alters reality, creates its own. And he knows, perhaps, that the camera, like the artist, lies to tell the truth. As an artist it is a truth he can live with.

MEL GOODING

Notes and references

Nadar is quoted from 'A Portrait of Nadar', by Maria Morris Hambourg, in *Nadar,* the catalogue to an exhibition at the Musée d'Orsay, June to September 1994, and at the Metropolitan Museum of Art, New York, from April to July 1995, p.25. The photographs described are reproduced as nos.33 and 34 and dated 1856–58 and 1855 respectively. Baudelaire is quoted from 'On the Ideal and the Model' in *The Salon of 1846,* 'Ingres' in *The Exposition Universelle 1855,* and on photography from 'The Modern Public and Photography' in *The Salon of 1859:* all to be found in *Art in Paris 1845–1862 Reviewed by Charles Baudelaire* (Phaidon, London 1965). For Brassaï on Picasso, see *Picasso and Co.* (Thames and Hudson, London 1966). Rosalind Krauss discusses 'Photography's Discursive Spaces' in the 1982 essay of that title reprinted in *The Originality of the Avant-Garde and other Modernist Myths* (MIT Press, Cambridge, Massachusetts and London, England, paperback edition 1986). *Private View* was published by Nelson, London, in 1965. *Moving Targets: A User's Guide to British Art Now* was published by Tate Gallery Publishing, London, in 1997.

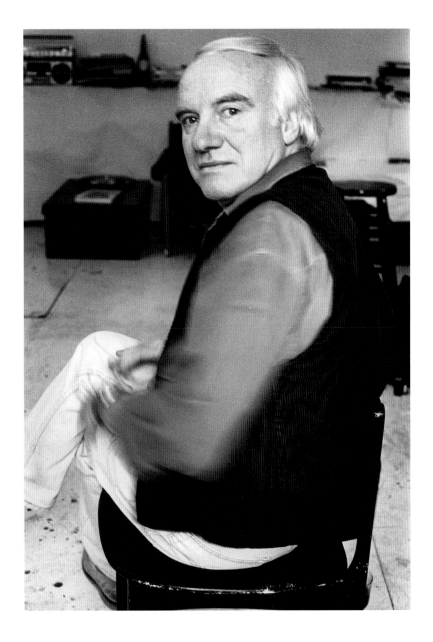

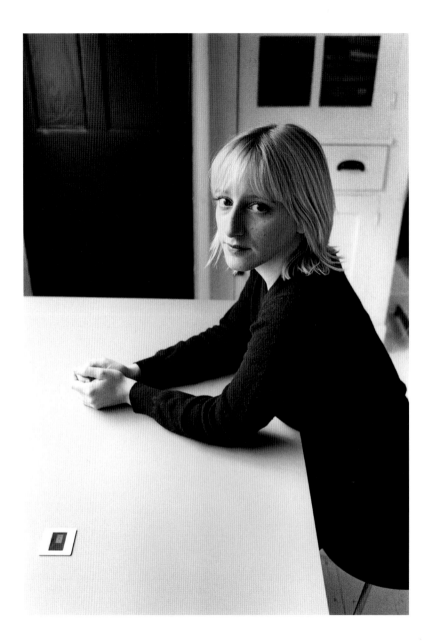

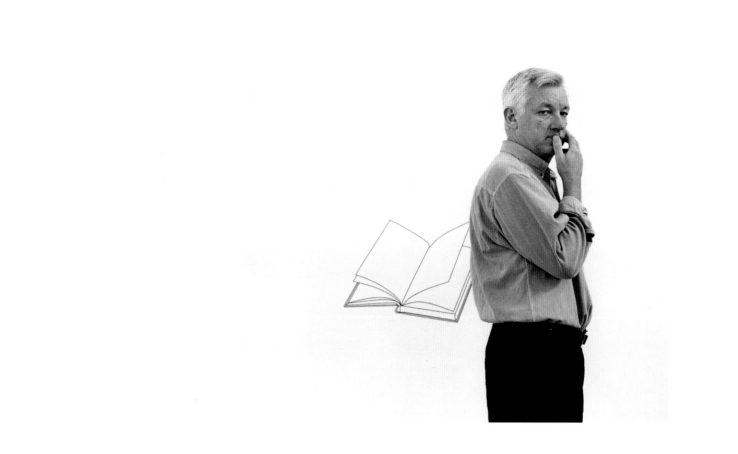

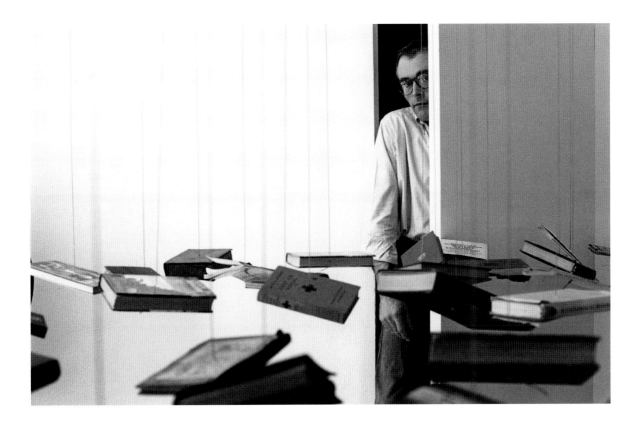

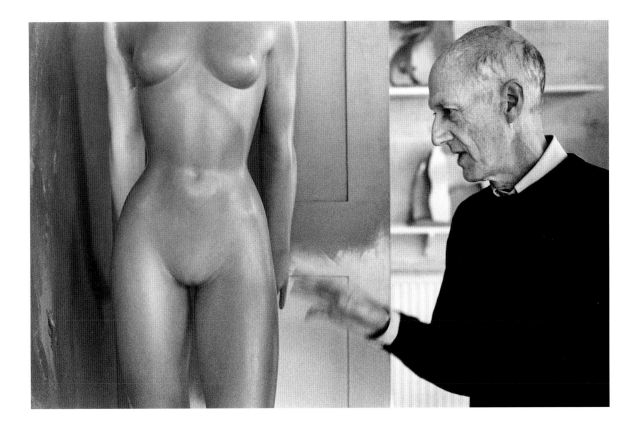

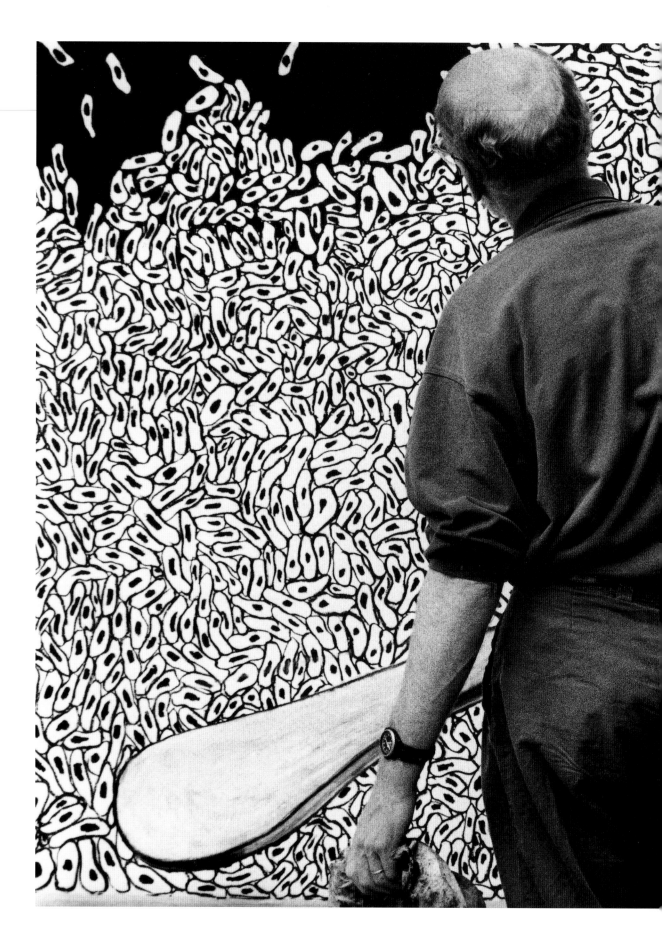

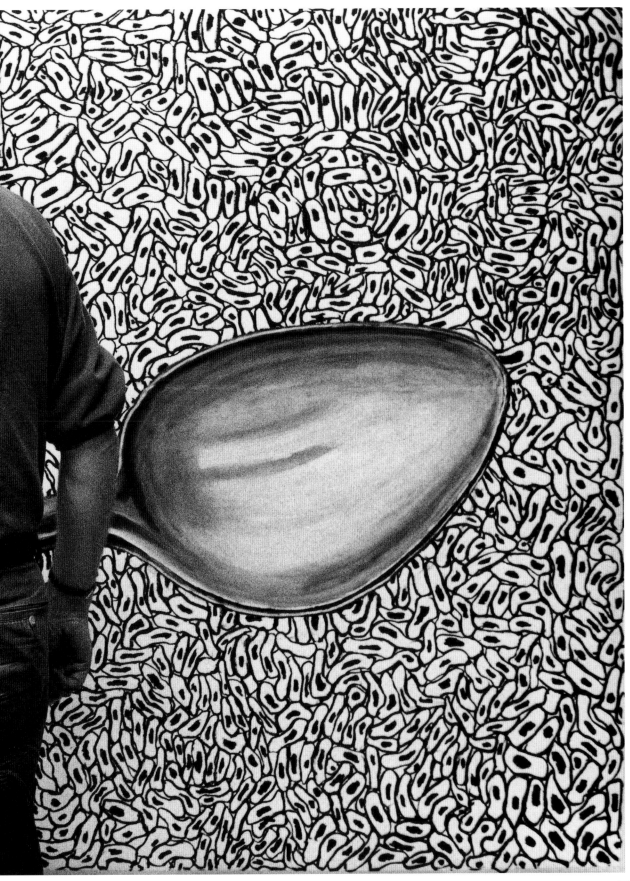

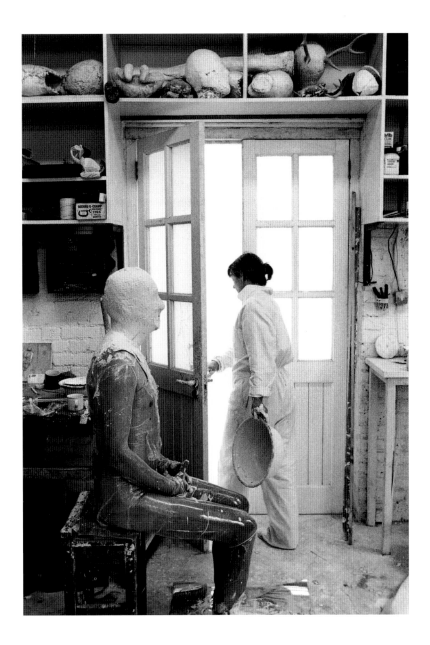

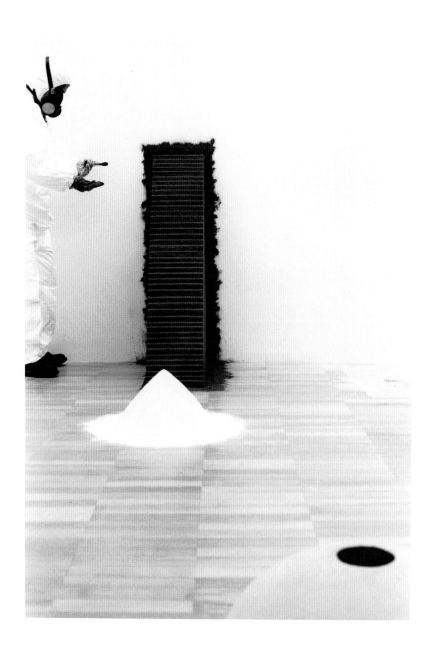

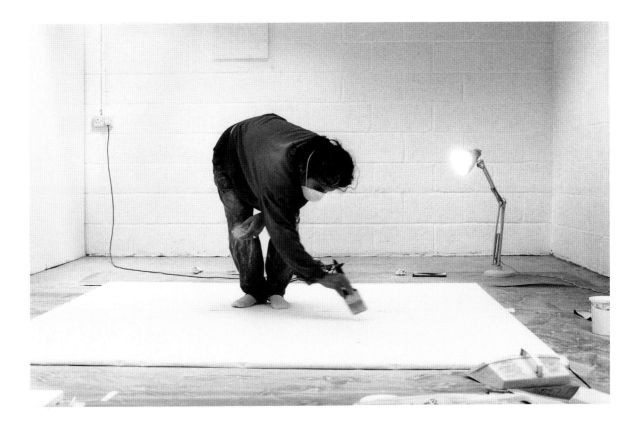

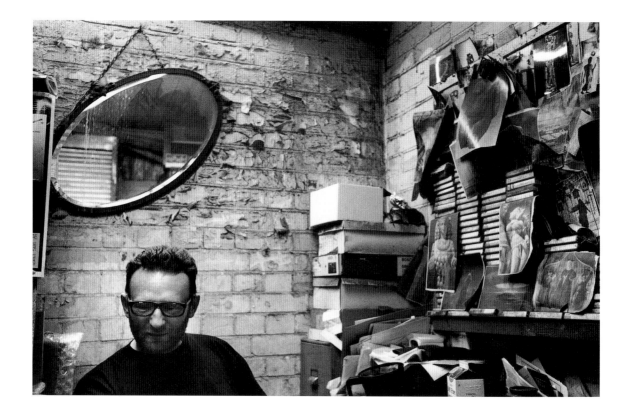

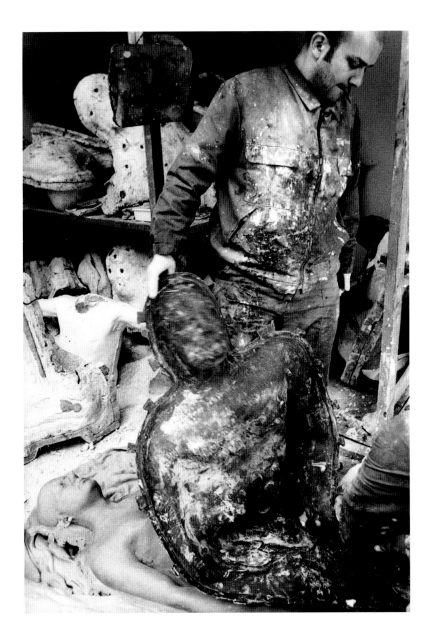

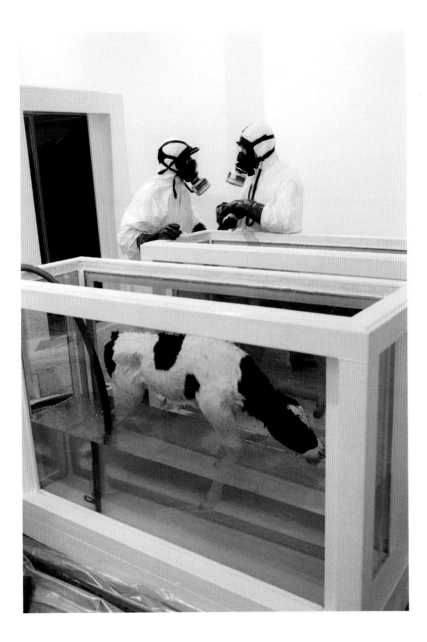

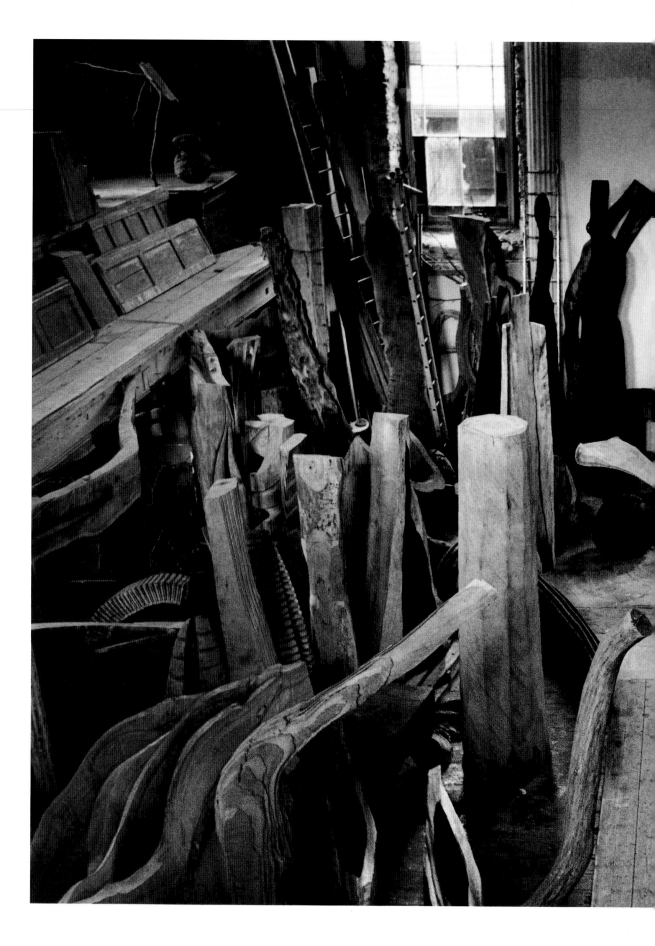

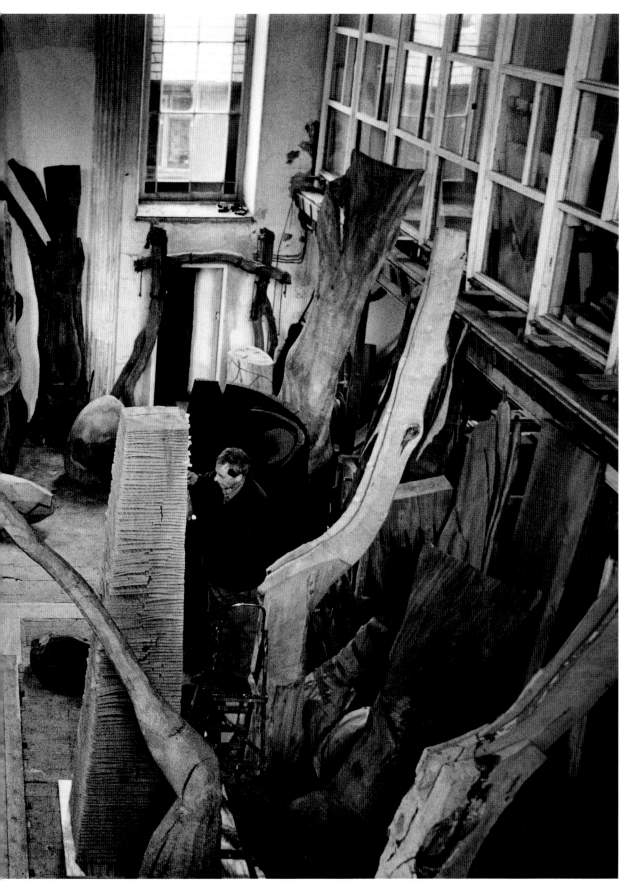

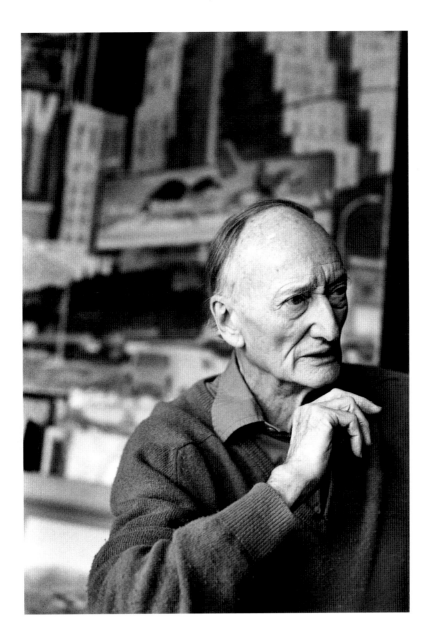

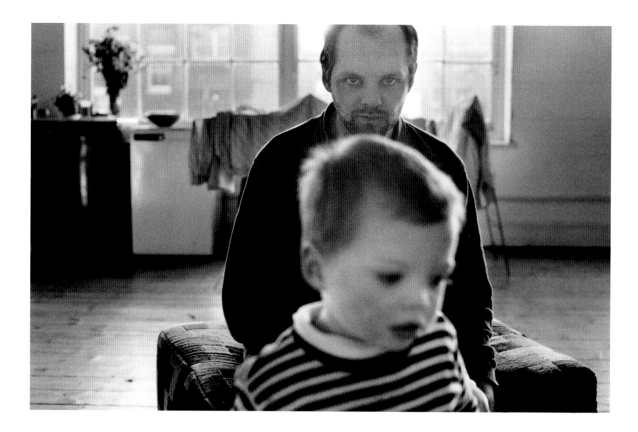

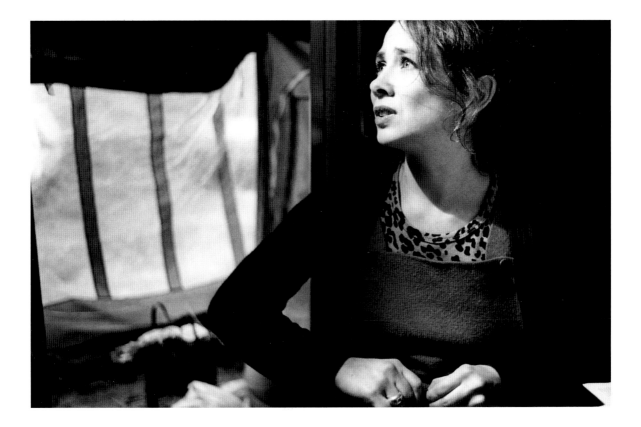

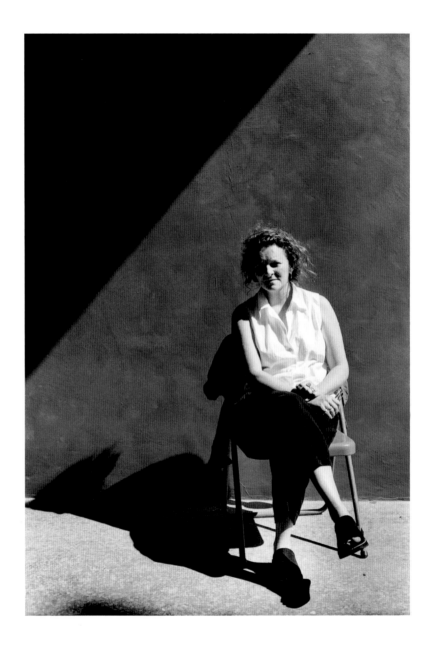

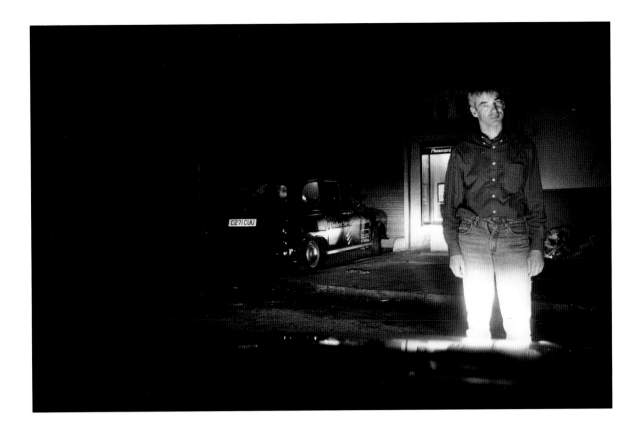

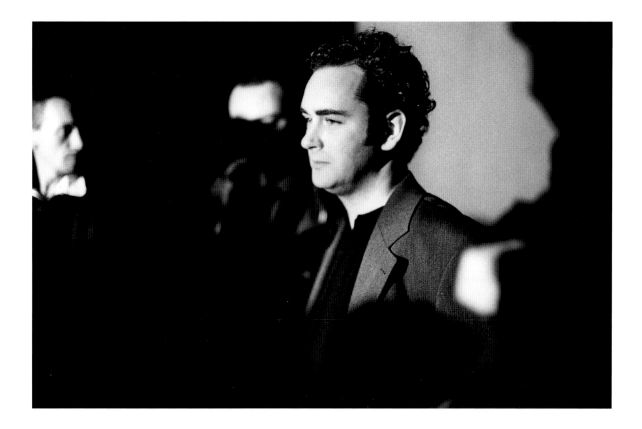

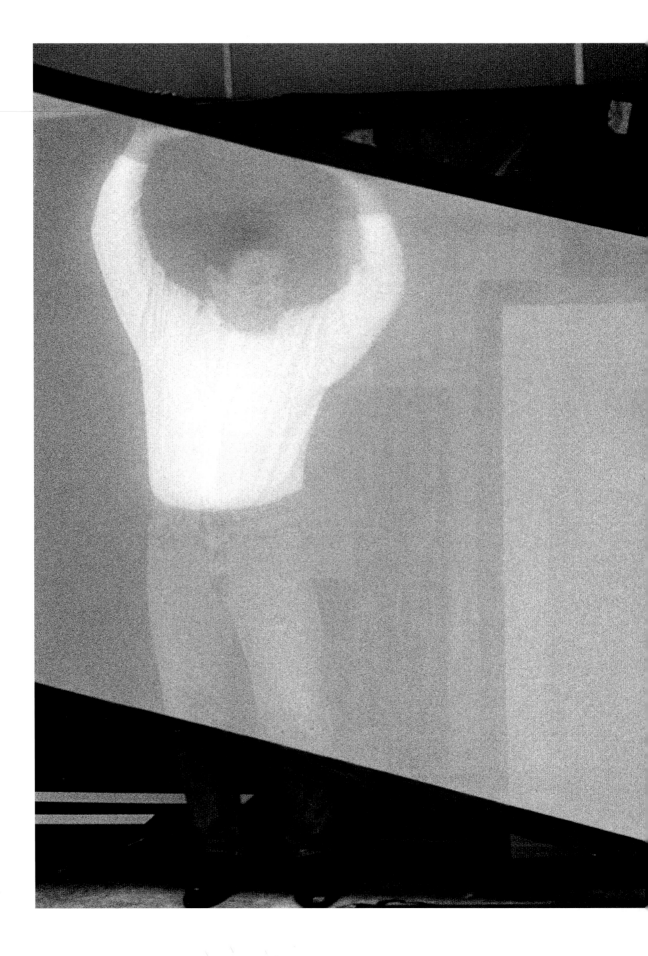

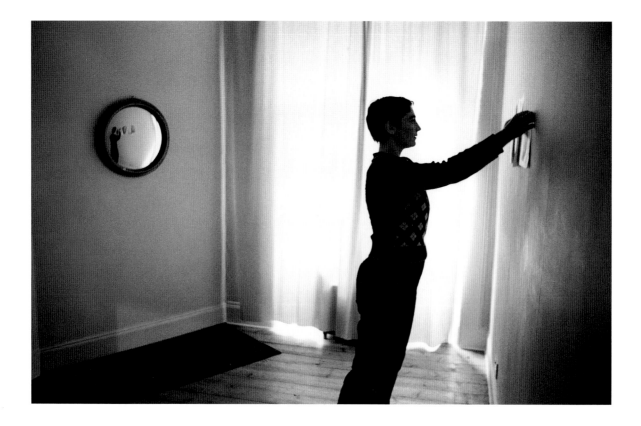

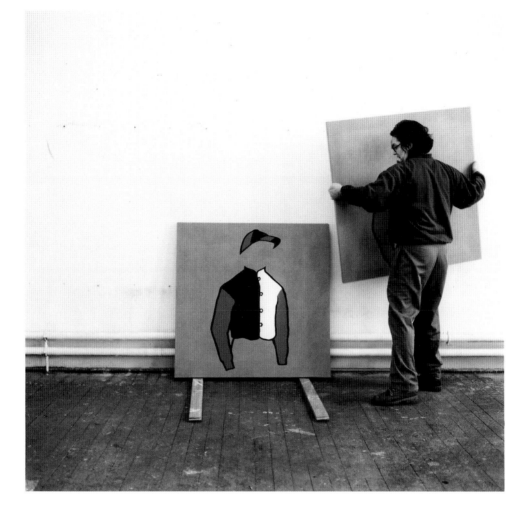

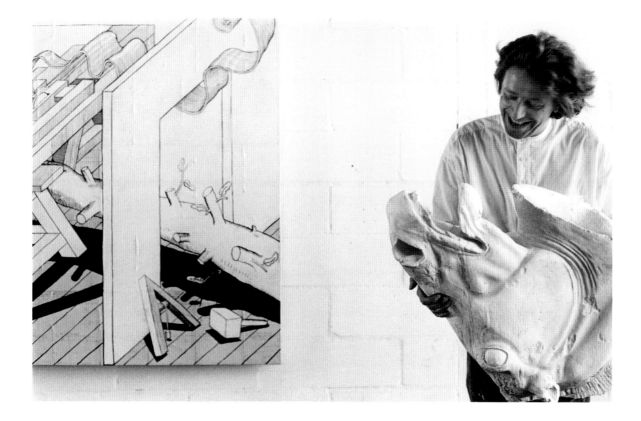

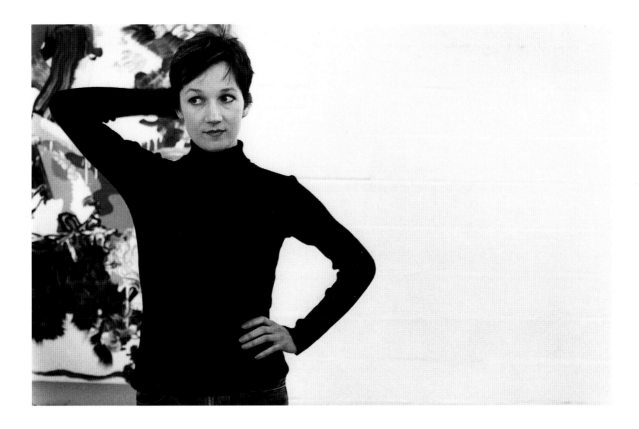

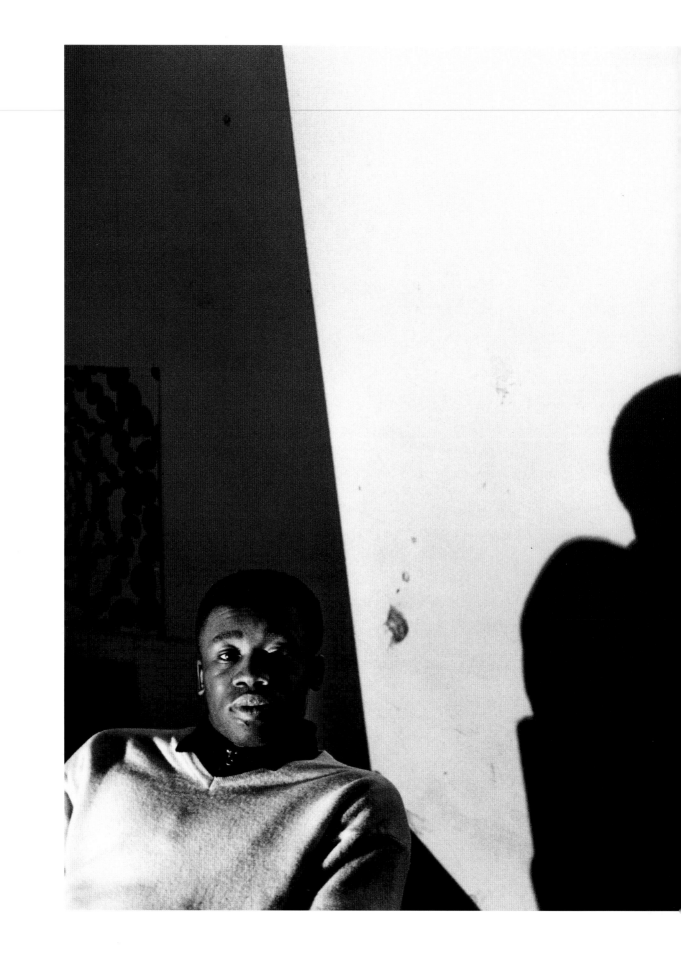

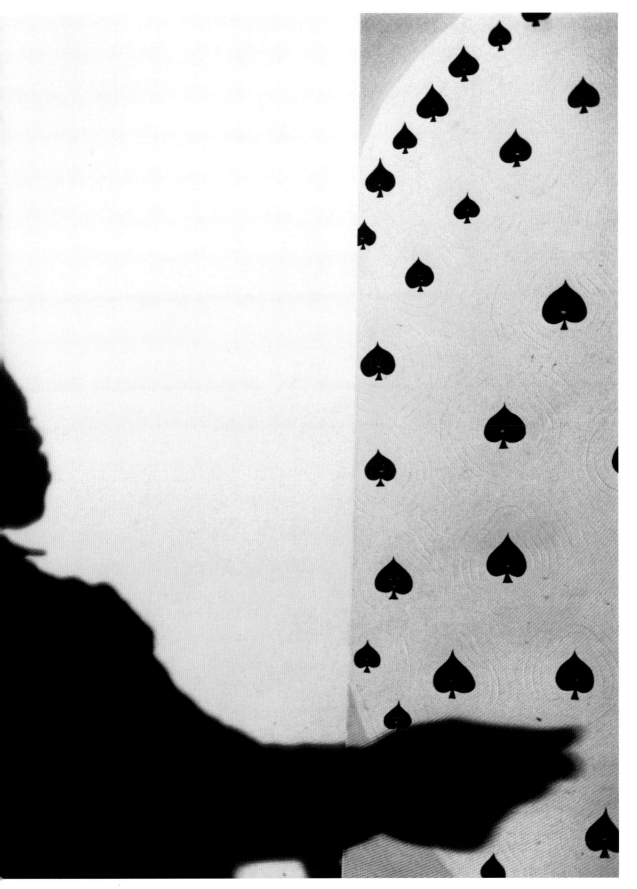

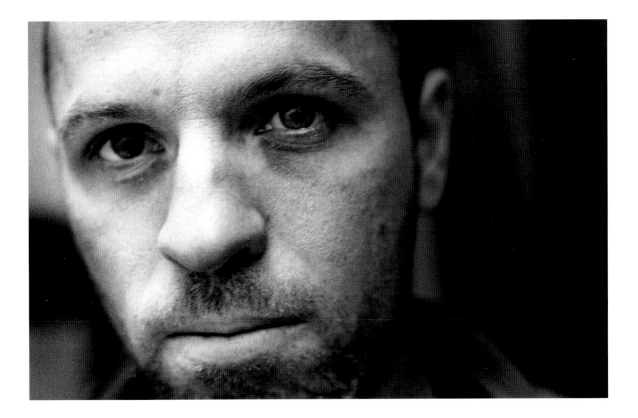

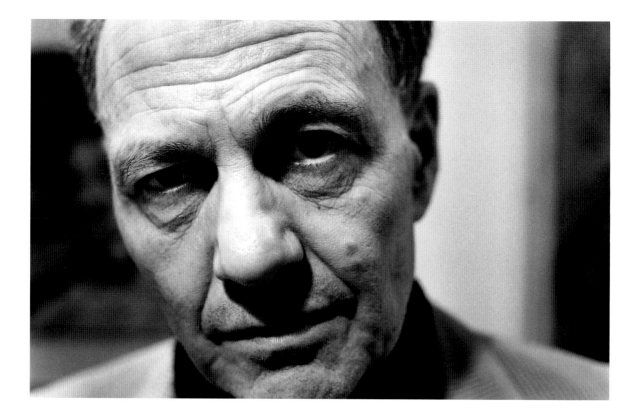

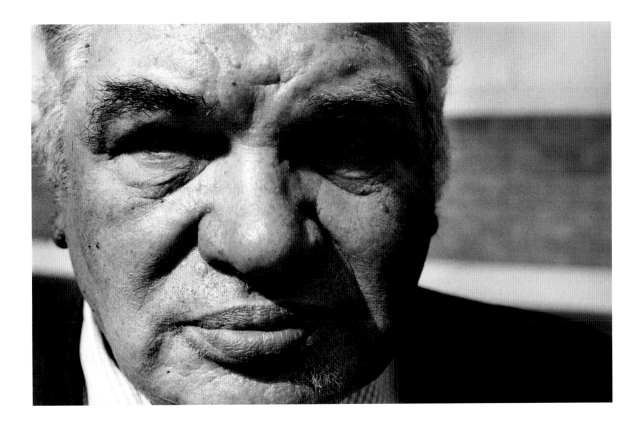

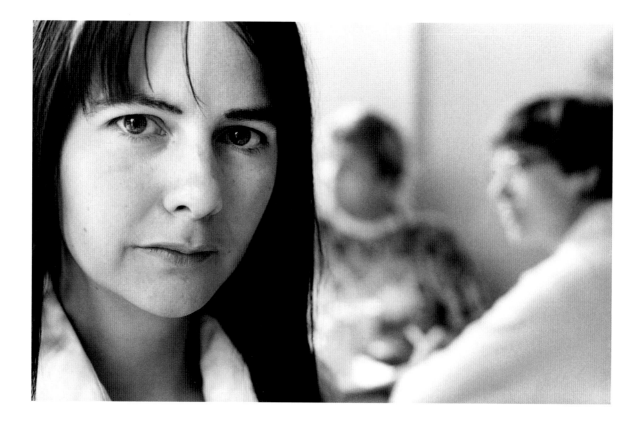

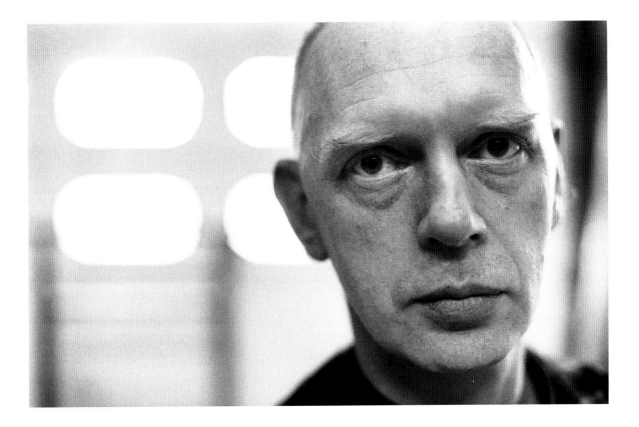

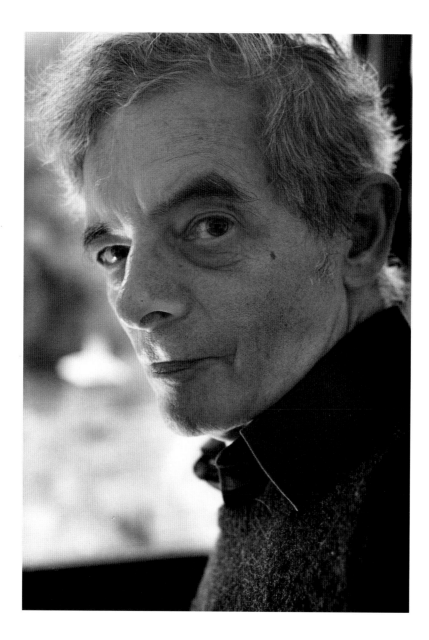

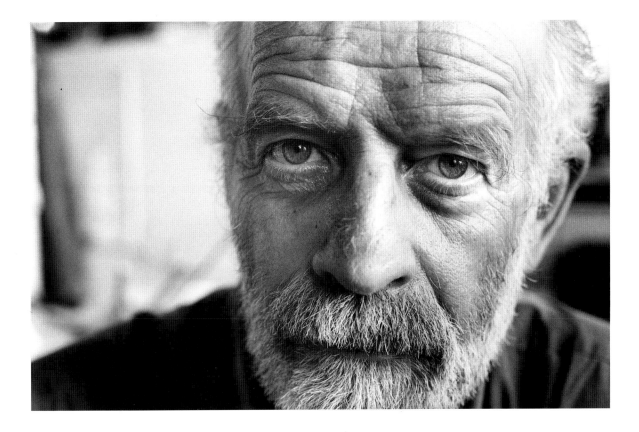

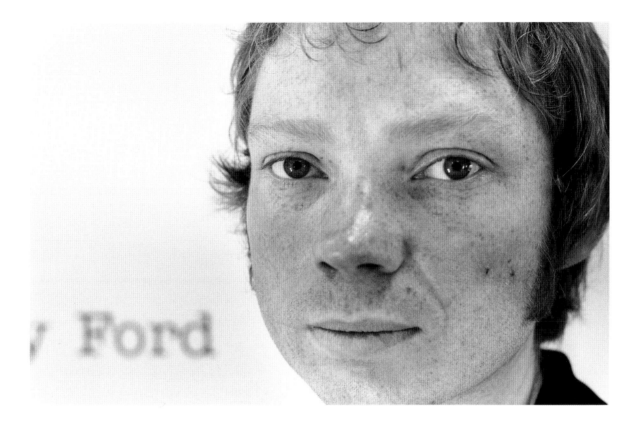

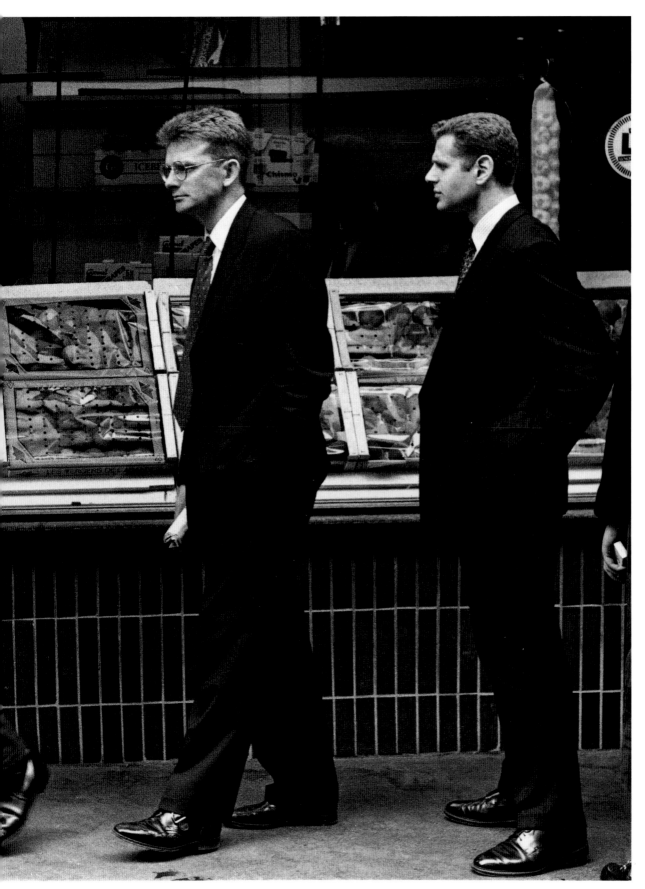

Grenville Davey | 65

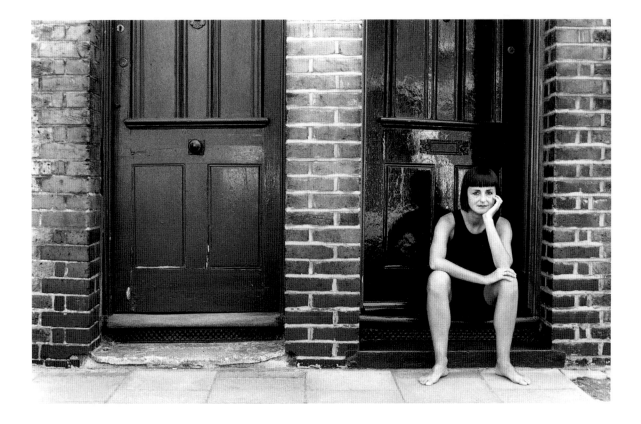

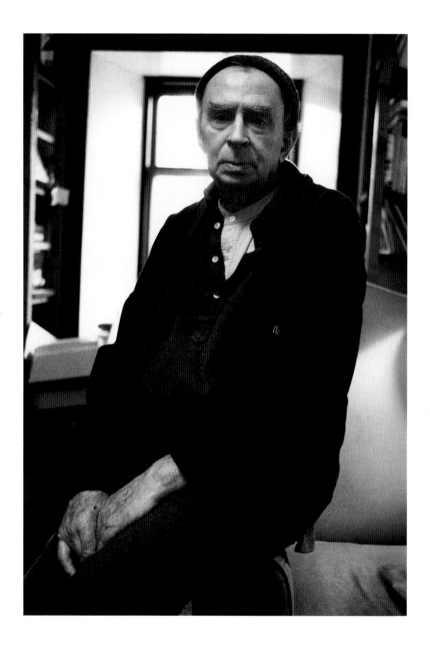

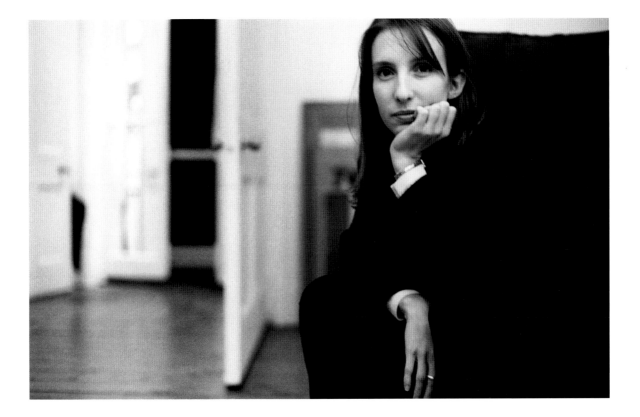

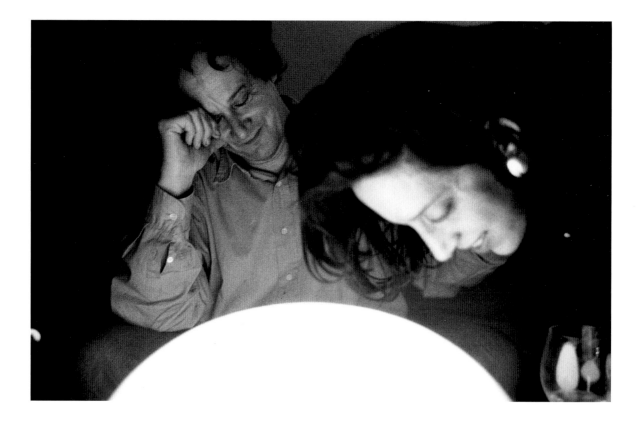

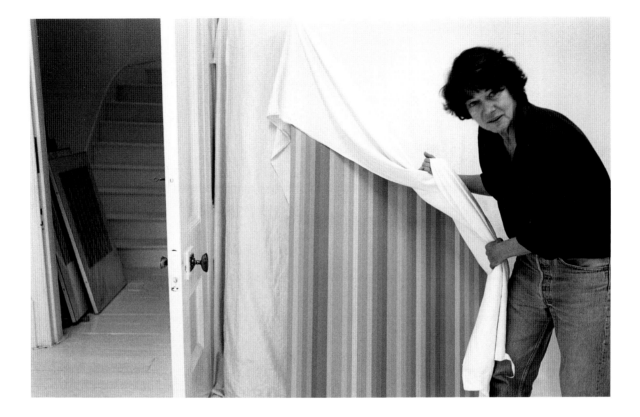

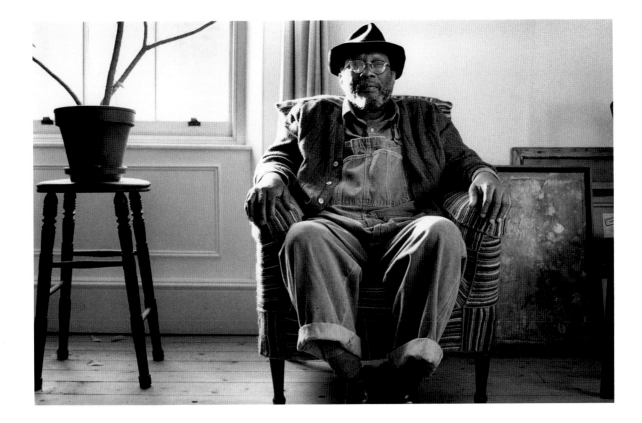

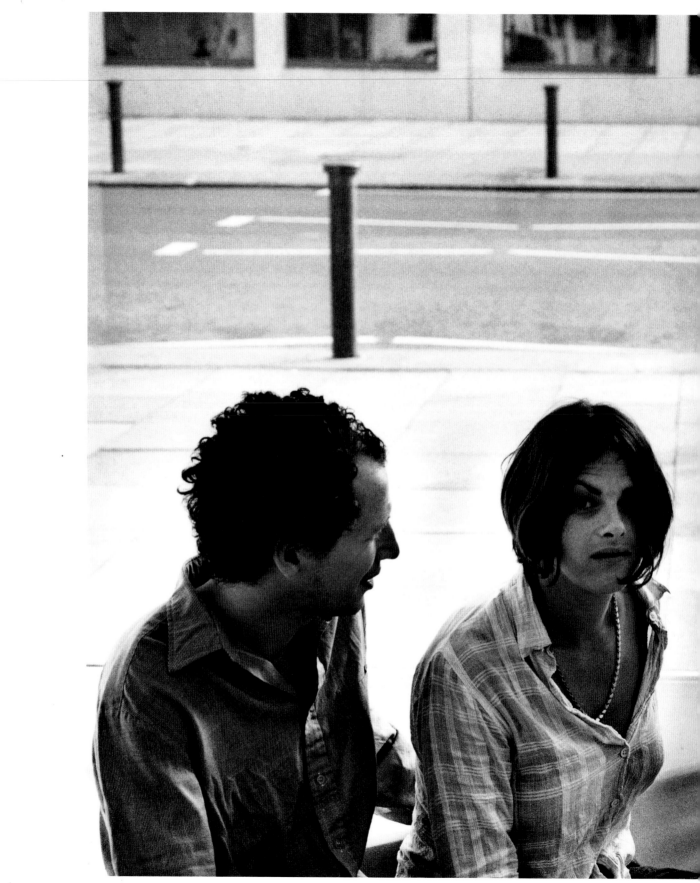

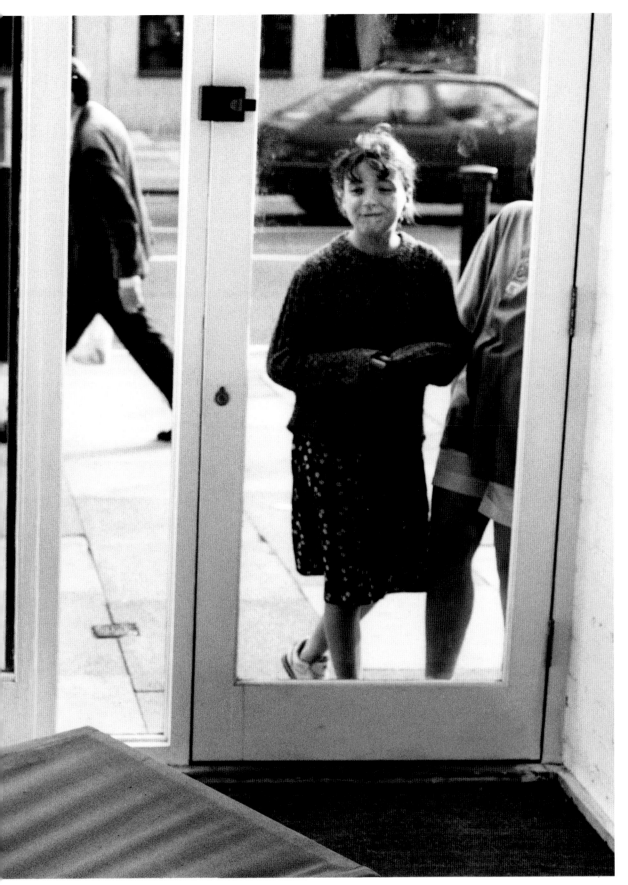

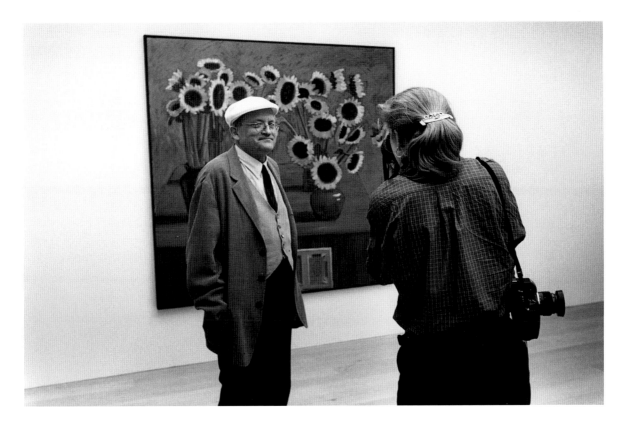

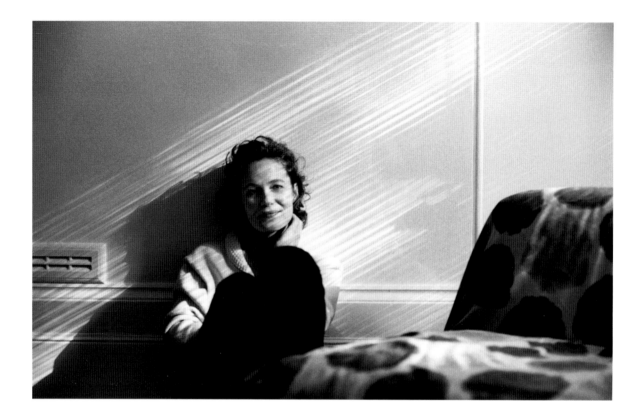

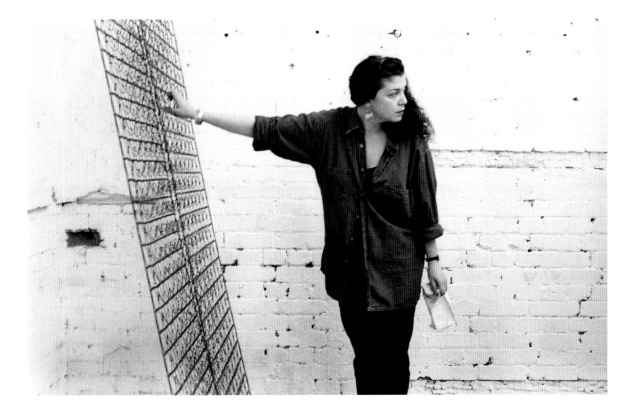

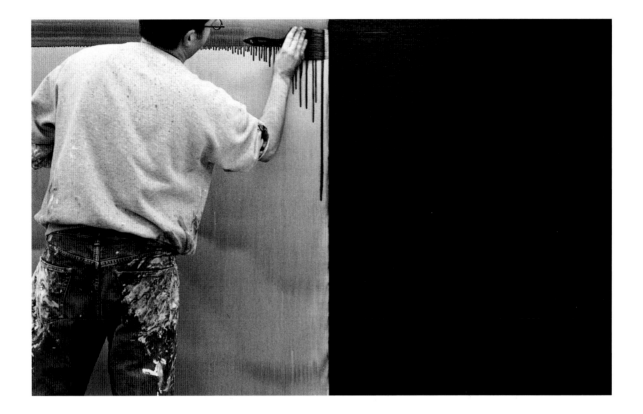

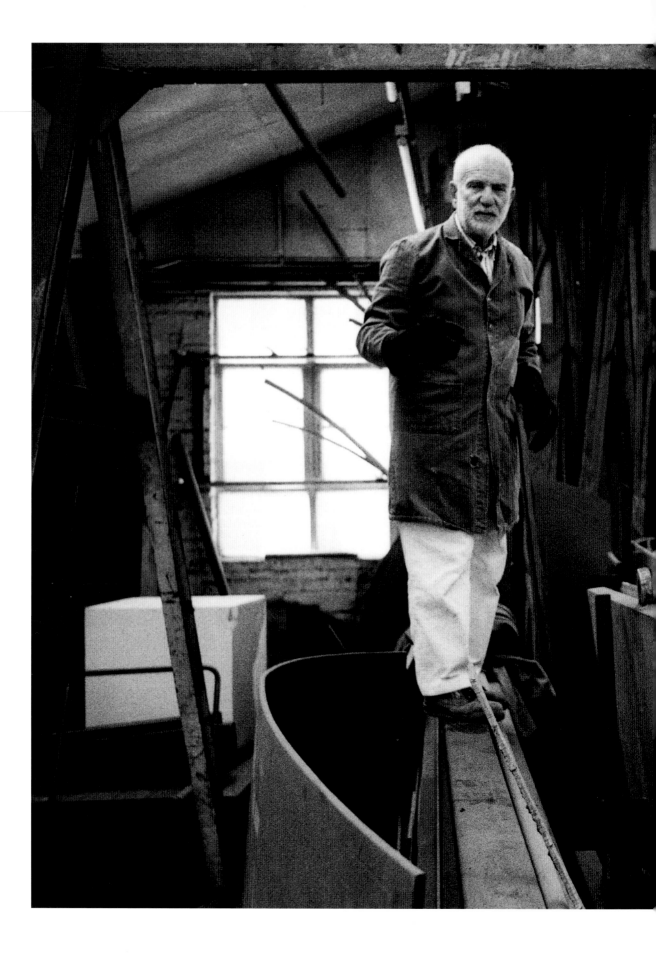

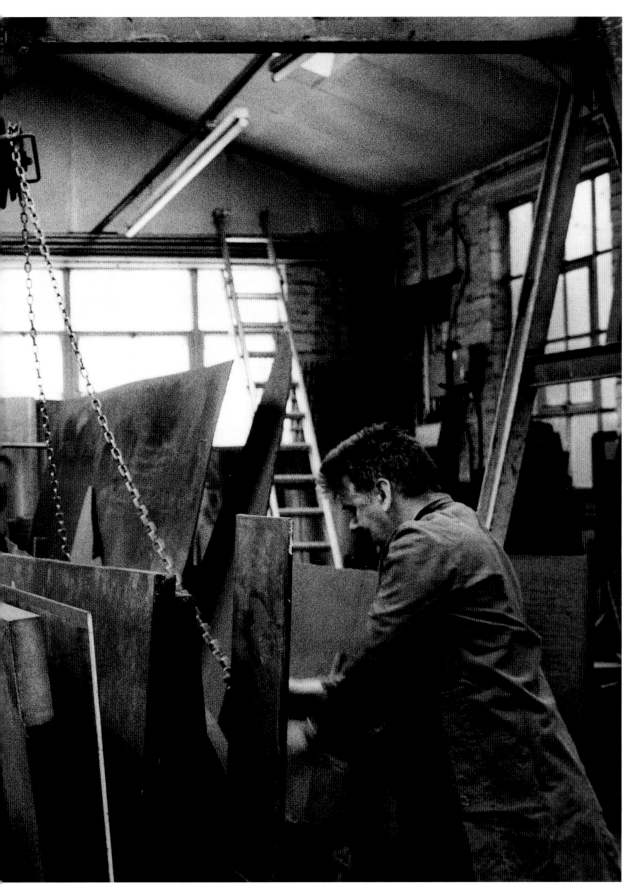

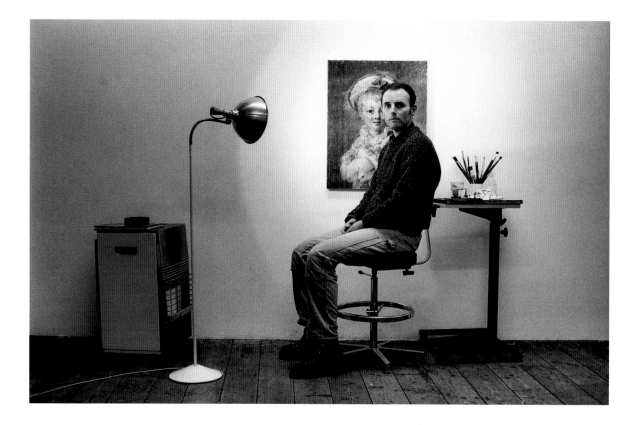

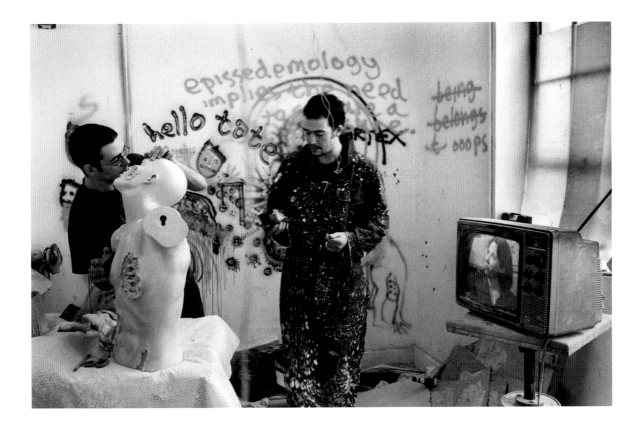

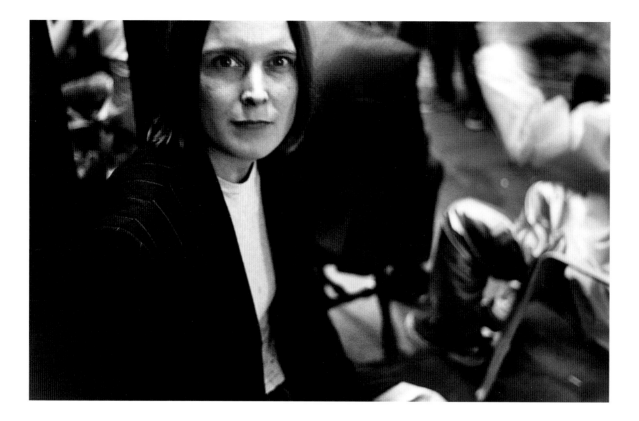

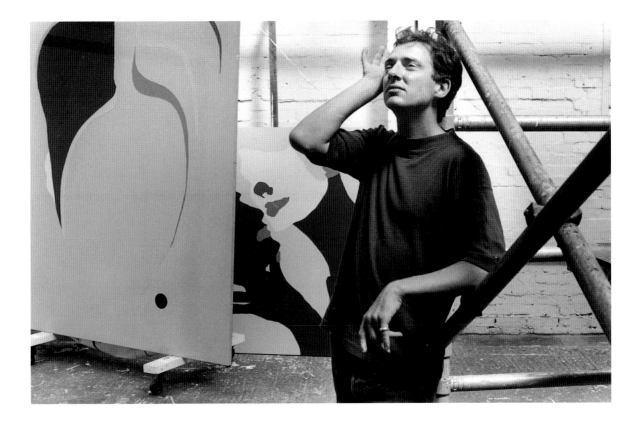

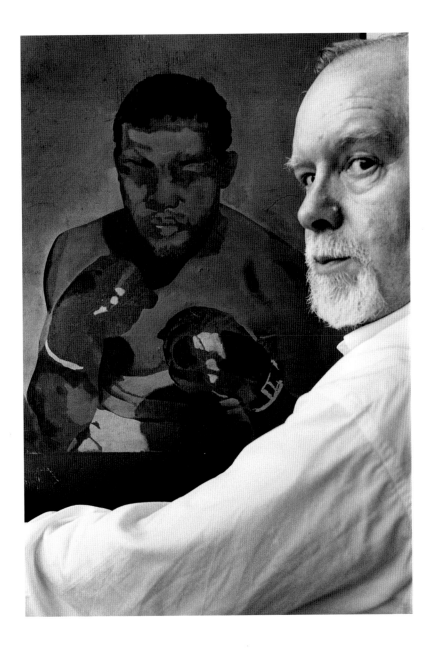

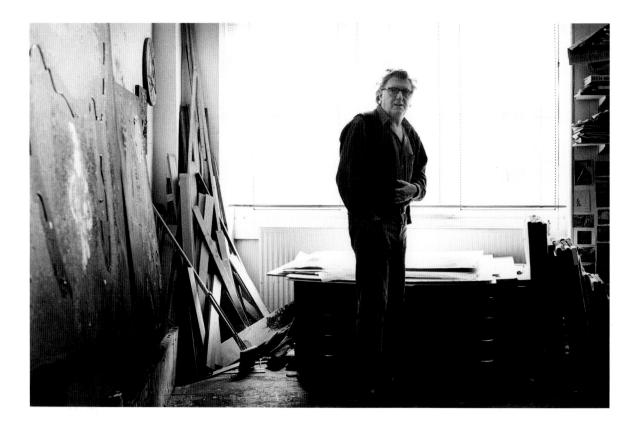

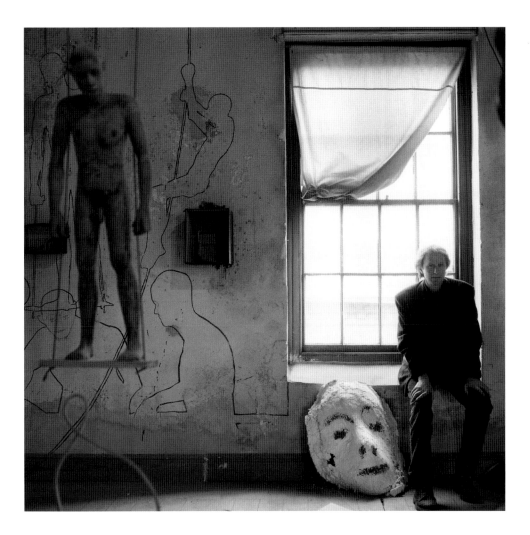

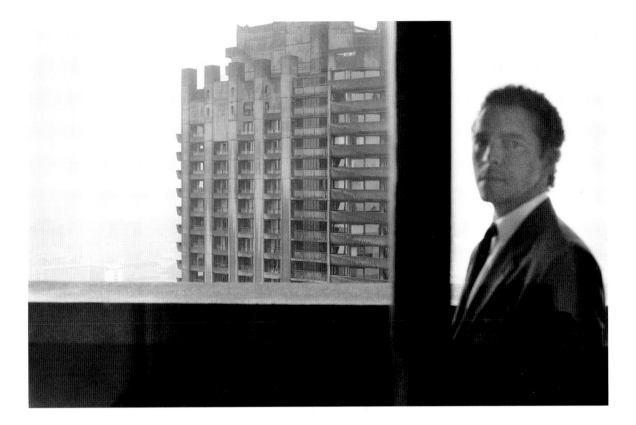

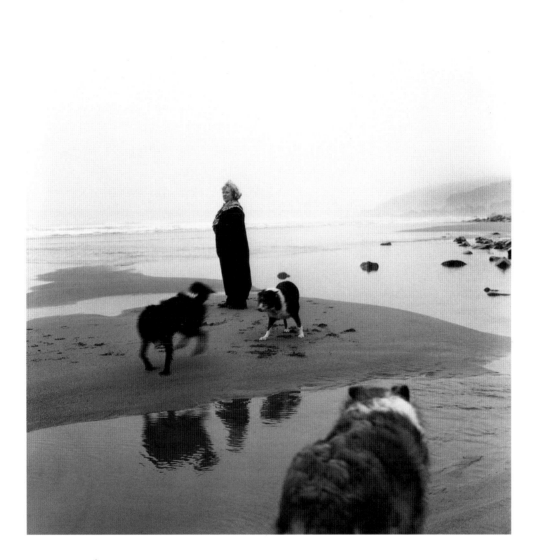

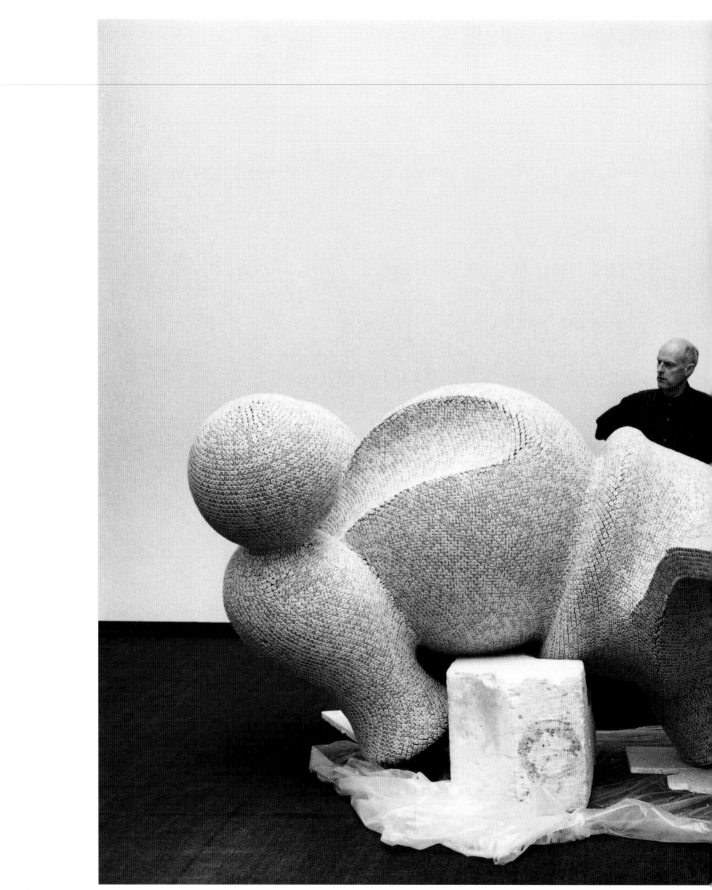

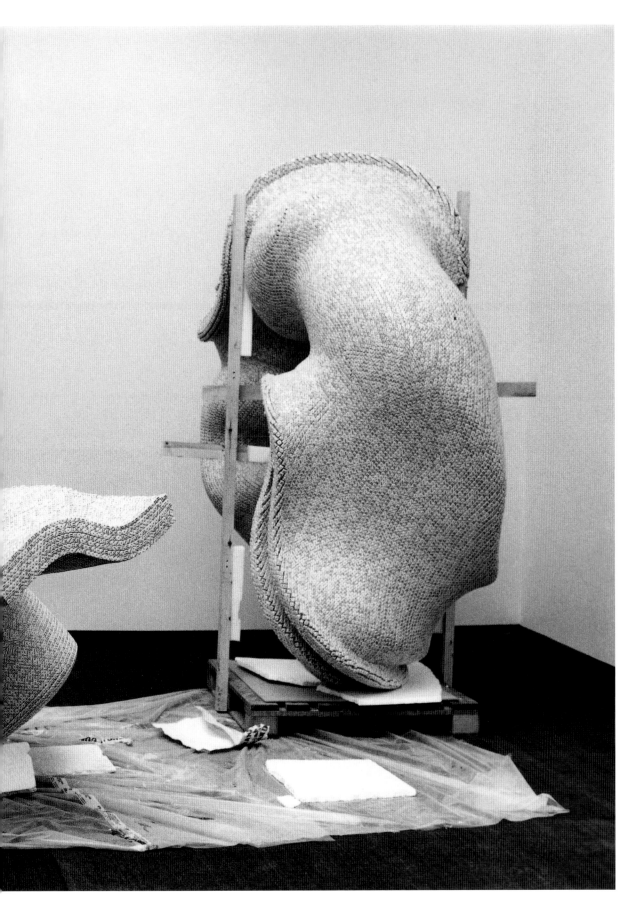

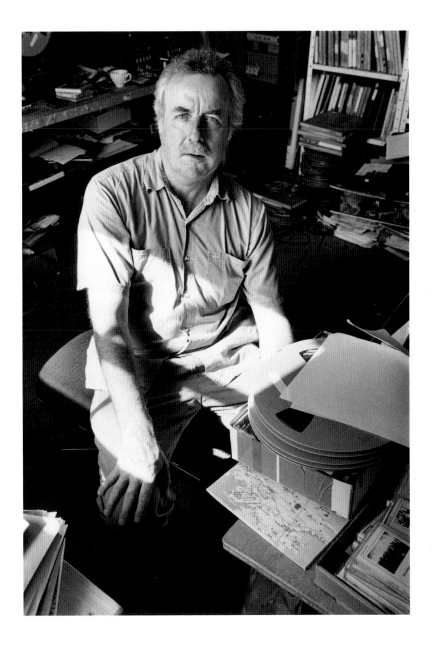

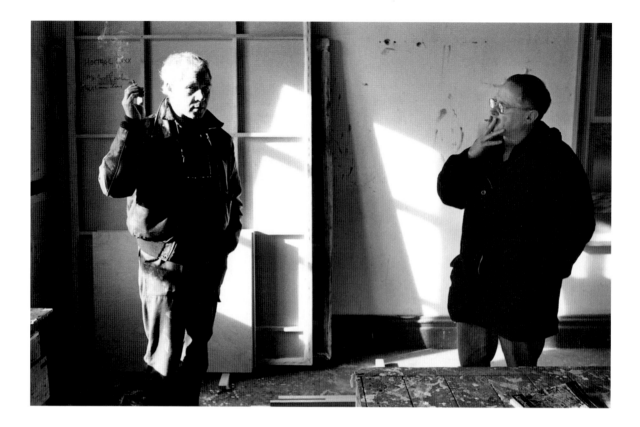

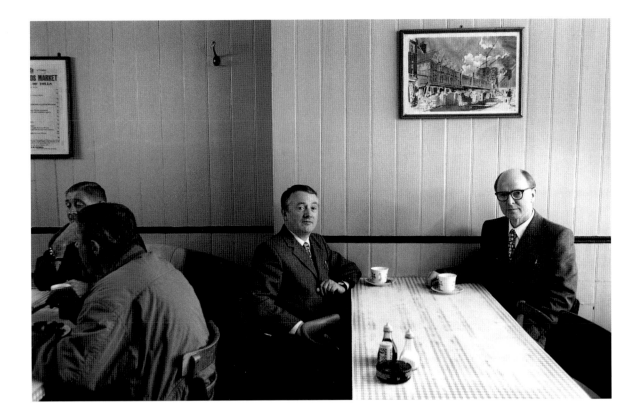

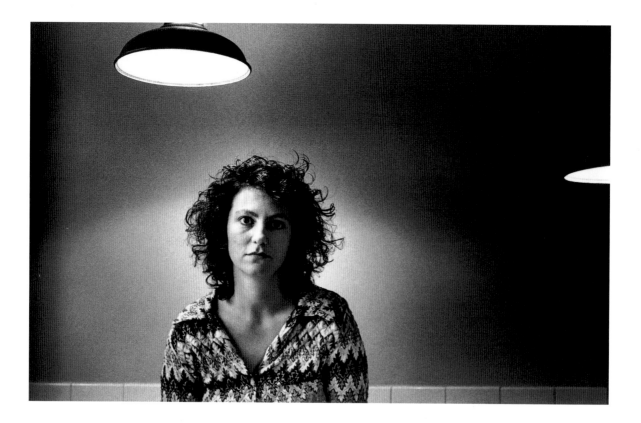

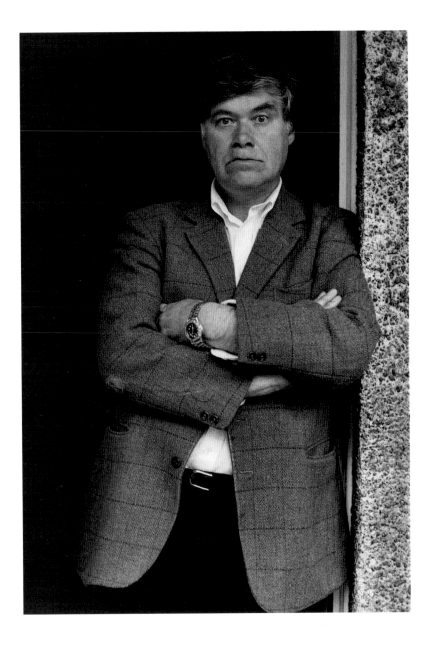

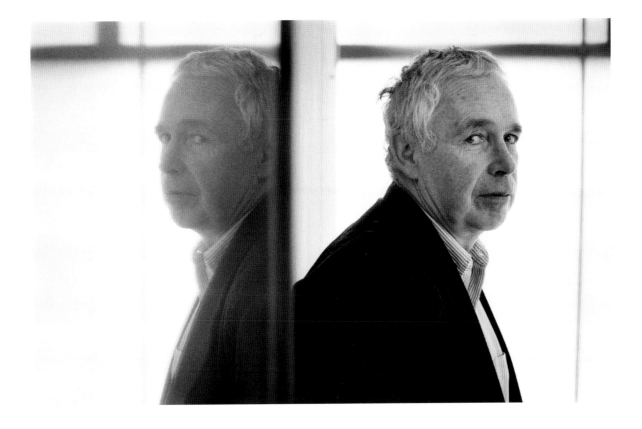

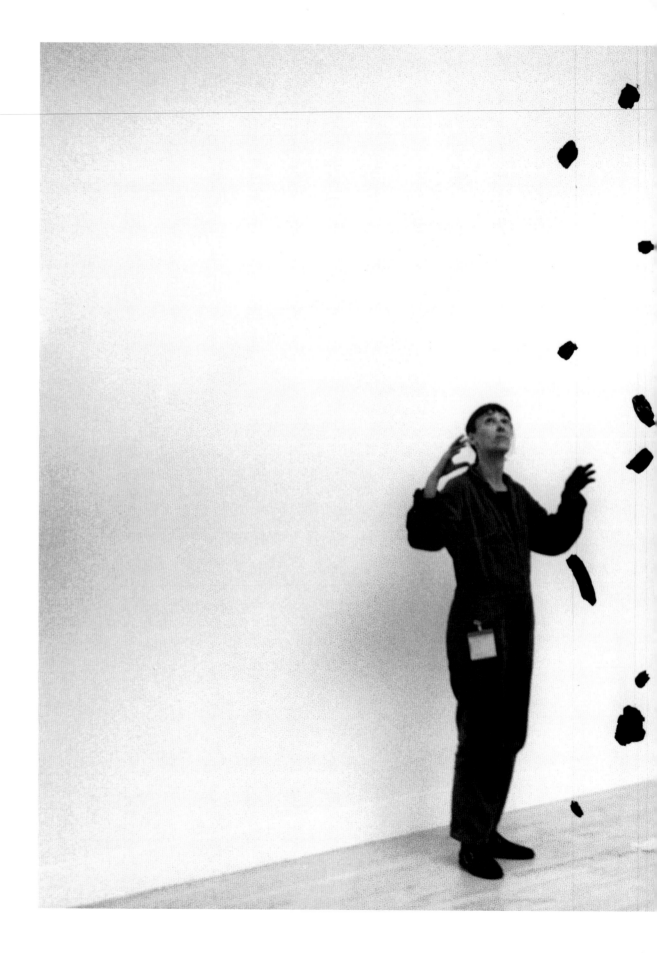

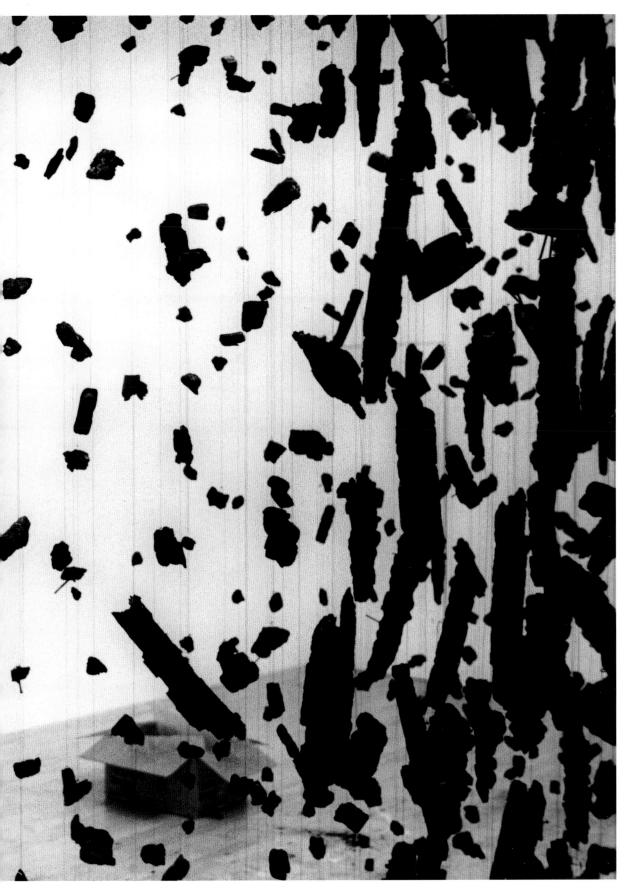

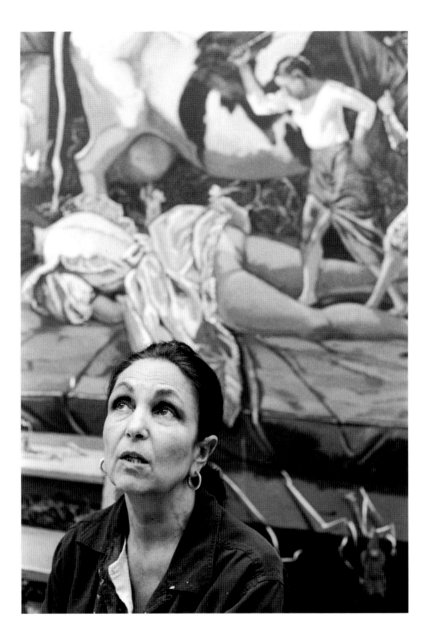

Moving through the entrance to the gallery looking towards Richard Wilson's space ········ moving ········ towards the stairs on the left ········ which lead up through ········ to this level ········ but not a part we're using. ········ There's the stairs down over there. I'm going to walk over there. ········ At the moment the stairs are covered with a piece of ········ Masonite but that can be moved. ········ Beyond the stairs there's the doors that lead through to the next part of the exhibition. ········ Through there ········ is the space we're looking at with Melanie. ········ There's a loading bay down there and a caged off area down there which I'm not looking at anything for particularly. ········ Back towards the little office and that entrance ········ through the stairs, up, seen from the back. This steel grill here will go ········ can go ········ stairs up into fog, through the ceiling structure supported by, I can't see anything here ········ that's it: supported by steel columns and goes straight into the roof, no pediment of any sort, no base r ········ In the middle of the room is this small sort of like lift well o something ········ timber construction, very rough ········ And in the fa corner by the entrance to the ongoing exhibition. That door over not in use. It's supposed to be closed ········ That's the downward ········ upward stair ········ Object in the middle of the room. That's point before you move into Melanie's space ········ The loading ba Not too clear on the viewfinder. Gives you an idea I guess. This the so far is an unused space and probably will stay that way ········ steel doors ········ past Melanie's ········ lift wells to the entrance of the exhibition ········ Now that's about Richard Wilson I think.

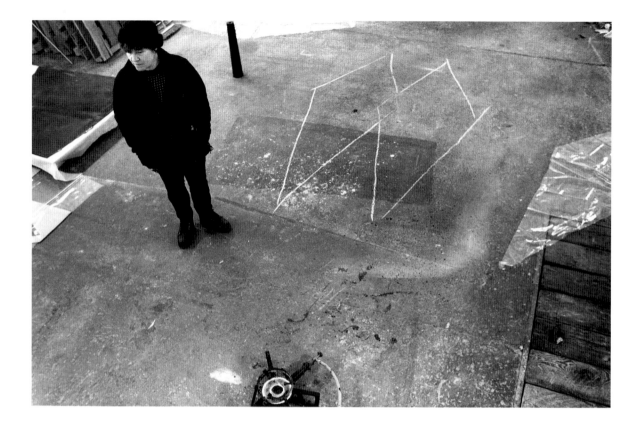

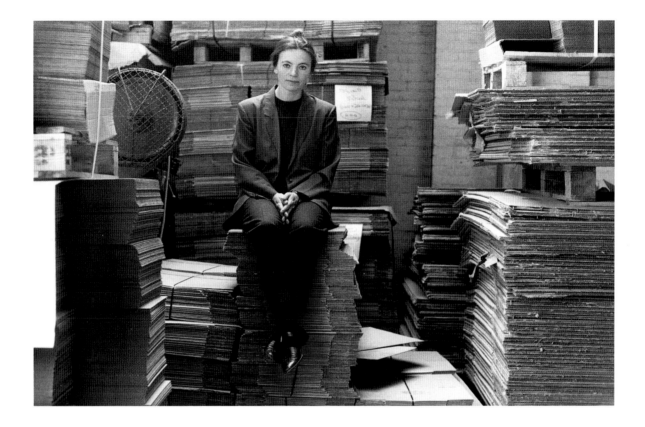

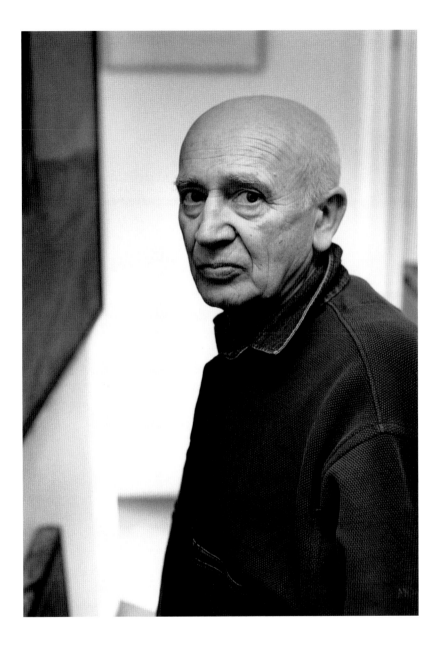

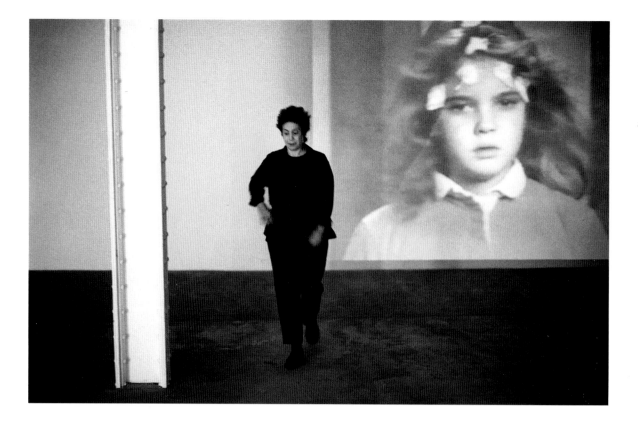

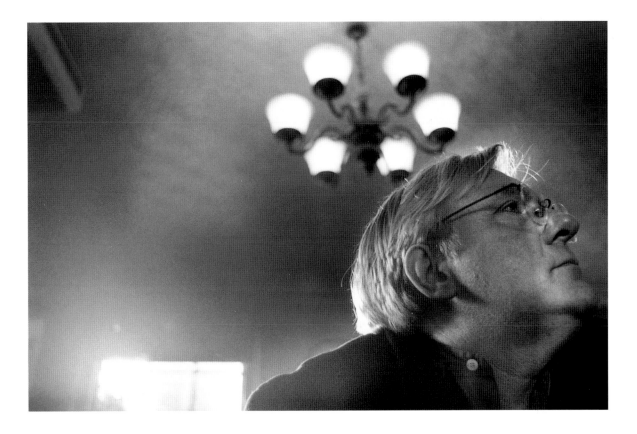

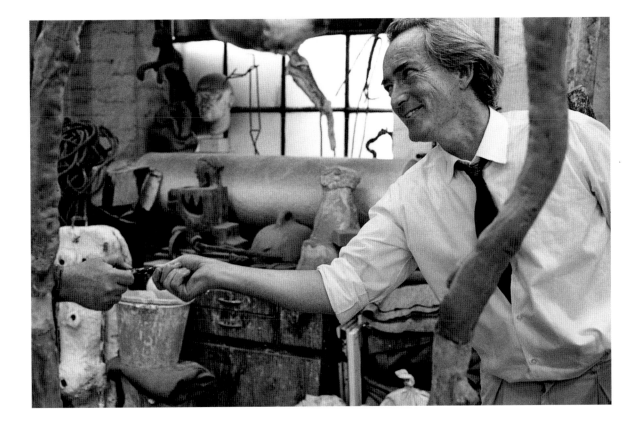

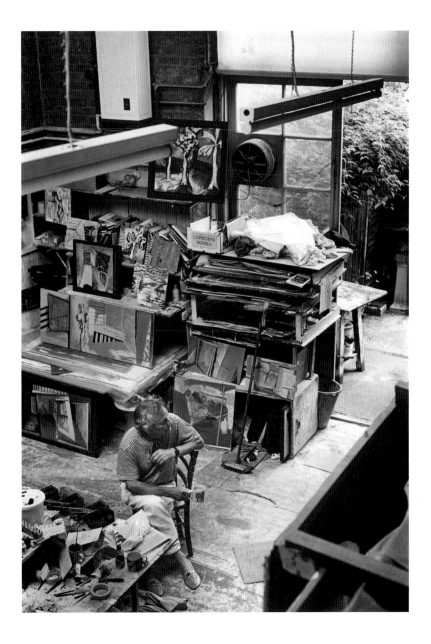

Artists live and work in London unless otherwise stated. If not given, location of gallery or place of publication is London.
CA = College of Art RCA = Royal College of Art SA = School of Art
RA = Royal Academy of Arts
The following exhibitions are cited in abbreviated form in the text:
Brilliant! New Art from London, Walker Art Center, Minneapolis and Museum of Contemporary Art, Houston, Texas 1995.
Here and Now, Serpentine Gallery 1995.
Un siècle de sculpture anglaise, Galerie nationale du Jeu de Paume, Paris 1996.
Sensation: Young British Artists from the Saatchi Collection, RA 1997.
Material Culture: The Object in British Art of the 1980s and 90s, Hayward Gallery 1997.

Edward Allington **49**
b. Troutbeck Bridge 1951. Lancaster CA 1968–71; Central SA 1971–4; RCA 1983–4. Recent solo exh.: Galerie Montenay, Paris 1993; Cornerhouse, Manchester 1993; Ikon Gallery, Birmingham 1993. Contrib. to group exh. since 1969, incl.: *Objects for the Ideal Home: The Legacy of Pop Art*, Serpentine Gallery 1991; Goodwood Sculpture Park 1997; *British Sculpture*, Schlosspark Ambras, Innsbruck 1998. Lit: *Edward Allington,* exh. cat., Bonner Kunstverein, Bonn 1992.

Art & Language
(Michael Baldwin and Mel Ramsden) **102**
Michael Baldwin: b. Chipping Norton 1945. Coventry CA 1964–7. Mel Ramsden: b. Ilkeston 1944. Nottingham SA 1960–2. Both artists live and work in Banbury. Recent solo exh.: Lisson Gallery 1994; Galeria Juana de Aizpuru, Madrid 1995; Gallerie Poo Poo 1998. Recent group exh.: *The Cutting Edge,* Barbican Art Gallery 1992; *1965–75: Reconsidering the Object of Art*, Museum of Contemporary Art (MOCA), Los Angeles 1995. Lit: *Art & Language,* exh. cat., Galerie nationale du Jeu de Paume, Paris 1992.

Frank Auerbach **56**
b. Berlin 1931. St Martins SA 1948–52; RCA 1952–5. Recent solo exh.: National Gallery 1995; Marlborough Fine Art 1997; Marlborough Gallery, NY 1998. Contrib. to group exh. since 1958, incl.: *A New Spirit in Painting*, RA 1981; *British Art in the 20th Century*, RA 1987; *The Pursuit of the Real: British Figurative Painting from Sickert to Bacon,* Manchester City Art Gallery 1990 (touring). Lit: R. Hughes, *Frank Auerbach,* London / NY 1990.

Gillian Ayres **97**
b. Barnes 1930. Camberwell SA 1946–50. Lives and works in Cornwall and London. Recent solo exh.: Tate Gallery 1995; RA 1997 (touring); Storey Institute Gallery, Lancaster 1998. Contrib. to group exh. since 1957, incl. *100 Years of Art in Britain*, Leeds City Art Gallery 1988; *Ready Steady Go: The Sixties: Art and Popular Culture in Britain,* Barbican Art Gallery 1993; *Home and Away: Internationalism and British Art 1900–1990*, Tate Gallery Liverpool 1995; *In/Sight,* University of Exeter 1998. Lit: *Gillian Ayres,* exh. cat., Serpentine Gallery 1983.

Peter Blake **89**
b. Dartford 1932. Gravesend SA 1949–51; RCA 1953–6. Recent solo exh.: Wetterling Gallery, Gothenburg 1990; Galerie Claude Bernard, Paris 1995; National Gallery 1996 (touring). Contrib. to group exh. since 1954, incl.: *London: The New Scene*, Walker Art Center, Minneapolis 1965 (touring); *The Ruralists*, Arnolfini, Bristol 1981 (touring); *Pop Art*, RA 1991 (touring). Lit: M. Vaizey, *Peter Blake,* 1986.

Christine Borland **46**
b. Darvel 1965. Glasgow SA 1983–7; University of Ulster, Belfast 1997–8. Lives and works in Glasgow. Recent solo exh.: Kunst-Werke, Berlin 1996; Lisson Gallery 1997; Museum für Gegenwartskunst, Zurich 1998. Contrib. to group exh. since 1990, incl.: *Kunst Europa,* Kunstverein Karlsruhe 1991; *Life/Live*, Musée d'art moderne de la ville de Paris 1996; *Material Culture* 1997; *Turner Prize*, Tate Gallery 1997. Lit.: V. Button, *The Turner Prize,* 1997.

Frank Bowling **73**
b. Bartica, Essequibo, Guyana 1936. Slade SA; RCA 1956–62. Lives and works in London and NY. Recent solo exh.: Camille Love Gallery, Atlanta, GA 1997; Christiane Nienaber Gallery, NY 1997; Rush Arts Gallery, NY 1998. Contrib. to group exh. since 1964, incl.; *Landscape as Metaphor,* Fitchburg Museum, MA 1993 (touring); *Caribbean Visions: Contemporary Painting and Sculpture*, Center for Fine Arts, Miami, FL 1995 (touring); *The African-American Fine Arts Collection of the New Jersey State Museum*, New Jersey State Museum, Trenton, NJ 1998. Lit.: Essay by M.R. Vendryes, in exh. cat, New Jersey State Museum 1998.

Glenn Brown **84**
b. Hexham 1966. Bath Academy of Art 1985–8; Goldsmiths College 1990–2. Recent solo exh.: Galerie Ghislaine Hussenot, Paris 1997; Patrick Painter Inc, Los Angeles 1998; Jerwood Foundation Gallery 1999. Contrib. to group exh. since 1989, incl.: *Brilliant!* 1995; *Sensation* 1997; *Abstract Painting, Once Removed*, Contemporary Arts Museum, Houston, Texas 1998. Lit: *Glenn Brown*, exh. cat., Queen's Hall Arts Centre, Hexham / Karsten Schubert, London 1997.

Anthony Caro **82**
b. New Malden 1924. Christ's College, Cambridge 1942–4; Regent St Polytechnic 1947; RA Schools 1947–52. Recent solo exh.: National Gallery, Athens 1997; National Gallery 1998; Annely Juda Fine Art 1998. Selected exh.: Museum of Modern Art (MOMA), NY 1975 (touring); Tate Gallery 1991: Whitworth Art Gallery, Manchester 1994. Lit: D. Blume, *The Sculpture of Anthony Caro: Catalogue Raisonné*, 5 vols., Cologne 1981–6.

Brian Catling **119**
b. London 1948. North East London Polytechnic 1968–71; RCA 1971–4. Lives and works in Oxford. Recent solo exh.: Serpentine Gallery 1994; South London Gallery 1996; Matt's Gallery 1998. Contrib. to group exh. since 1974, incl.: Ujazdowski Centre of Contemporary Art, Warsaw 1993; The Reading Room at The British Library / The Castle Mound, Oxford 1994; Bergen Performance Festival 1997. Lit: *Soundings: A Tractate of Absence,* exh. cat., Matt's Gallery 1992.

Patrick Caulfield **17**
b. London 1936. Chelsea SA 1956–60; RCA 1960–3. Recent solo exh.: Serpentine Gallery 1992; Waddington Galleries 1997; Hayward Gallery 1999 (touring). Contrib. to group exh. since 1961, incl.: 18 Bienal de São Paulo, Brazil 1985; *Pop Art,* RA 1991 (touring); *Here and Now* 1995. Lit: *Patrick Caulfield,* exh. cat., Hayward Gallery 1999.

Helen Chadwick **67**
b. Croydon 1953, d. London 1996. Brighton Polytechnic 1973–6; Chelsea SA 1976–7. Recent solo exh.: MOMA, NY 1995 (touring); Eugen Lendl, Graz 1996; Portfolio Gallery, Edinburgh 1996. Contrib. to group exh. since 1977, incl.: *Féminin–Masculin, le sexe de l'art,* Centre Georges Pompidou, Paris 1995; *Home and Away: Internationalism and British Art 1900–1990,* Tate Gallery Liverpool 1995; *Body Visual,* Barbican Art Gallery 1996. Lit.: M. Warner and H. Chadwick, *Enfleshings,* London / NY 1989.

Jake and Dinos Chapman **85**
Dinos Chapman: b. London 1962. Ravensbourne CA 1979–81; RCA 1988–90. Jake Chapman: b. Cheltenham 1966. North East London Polytechnic 1985–8; RCA 1988–90. Recent solo exh.: Grazer Kunstverein, Graz 1997; Gagosian Gallery, NY 1997; Galerie Daniel Templon, Paris 1998. Group exh. incl.: *Brilliant!* 1995; *Sensation* 1997; *Wounds: Between Democracy and Redemption in Contemporary Art,* Moderna Museet, Stockholm 1998. Lit.: *Sensation,* exh. cat. 1997.

Alan Charlton **90**
b. Sheffield 1948. Sheffield SA 1965–6; Camberwell SA 1966–9; RA Schools 1969–72. Recent solo exh.: Victoria Miro Gallery 1993; John Gibson Gallery, NY 1994; Galerie Stadtpark, Krems 1995. Contrib. to group exh. since 1972, incl.: *Singular Dimensions in Painting,* Guggenheim Museum, NY 1993; *From Here,* Waddington Galleries 1995; *Arterias,* Malmö Konsthall 1998. Lit: *Alan Charlton,* exh. cat., Museum Haus Esters, Krefeld 1992.

Tony Cragg **98**
b. Liverpool 1949. Wimbledon SA 1969–72; RCA 1973–7. Lives and works in Germany. Recent solo exh.: Centre Georges Pompidou, Paris 1996; Whitechapel Art Gallery 1997; Lisson Gallery 1998. Contrib. to group exh. since 1975, incl.: *Here and Now* 1995; *Un siècle de sculpture anglaise* 1996; Goodwood Sculpture Park 1997. Lit.: *Tony Cragg,* exh. cat., Centre Georges Pompidou, Paris 1996.

Michael Craig-Martin **20**
b. Dublin 1941. Yale University, New Haven, Conn. 1961–3. Recent solo exh.: Kunstverein für die Rheinlande und Westfalen, Düsseldorf 1997; Kunstverein Hannover 1998; Wurttembergischer Kunstverein, Stuttgart 1999. Contrib. to group exh. since 1970, incl.: *Here and Now* 1995; *The Adventure of Painting,* Kunstverein für die Rheinlande und Westfalen, Düsseldorf 1995 (touring); *Un siècle de sculpture anglaise* 1996. Lit.: *Michael Craig-Martin: A Retrospective 1968–89,* exh. cat., Whitechapel Art Gallery 1989.

Grenville Davey **64**
b. Launceston 1961. Exeter CA 1981–2; Goldsmiths College 1982–5. Recent solo exh.: Württembergischer Kunstverein, Stuttgart 1994; Galleria Primo Piano, Rome 1996; University of East London 1997. Contrib. to group exh. since 1986, incl.: *OBJECTives: The New Sculpture,* Newport Harbor Art Museum, Newport Beach, CA 1990; *Objects for the Ideal Home: The Legacy of Pop Art,* Serpentine Gallery 1991; *Turner Prize,* Tate Gallery 1992; *Material Culture* 1997. Lit.: *Grenville Davey,* exh. cat., Kunsthalle, Bern / Kunstverein für die Rheinlande und Westfalen, Düsseldorf 1992.

John Davies **93**
b. Cheshire 1946. Hull and Manchester CAs 1963–7; Slade SA 1967–9. Lives and works in Greece and London. Recent solo exh.: Centro de Arte Palacio Almundi, Murcia 1995; Whitworth Art Gallery, Manchester 1996; Marlborough Fine Art 1997. Contrib. to group exh. since 1973, incl.: *100 Years of Art in Britain,* Leeds City Art Gallery 1988; *Bodyworks,* Kettle's Yard, Cambridge 1997; *Surrealism and After,* Scottish National Gallery of Modern Art, Edinburgh 1997. Lit.: E. Lucie-Smith, *Sculpture since 1945,* 1987.

Richard Deacon **59**
b. Bangor 1949. St Martins SA 1969–72; RCA 1974–7; Chelsea SA 1977–8. Recent solo exh.: British Council touring exh.1996; Galerie Arlogos, Paris 1998; Tate Gallery Liverpool 1999. Contrib. to group exh. since 1970, incl.: *Here and Now* 1995; *Un siècle de sculpture anglaise* 1996; *Material Culture* 1997. Lit: *Richard Deacon: New World Order,* exh. cat., Tate Gallery Liverpool 1999.

Peter Doig **55**
b. Edinburgh 1959. Wimbledon SA 1979–80; St Martins SA 1980–3; Chelsea SA 1989–90. Recent solo exh.: Victoria Miro Gallery 1996; Kunsthalle, Nürnberg 1998; Whitechapel Art Gallery 1998. Contrib. to group exh. since 1982, incl.: *Turner Prize,* Tate Gallery 1994; *Here and Now* 1995; *About Vision: New British Painting in the 1990s,* MOMA, Oxford 1996; Laing Art Gallery, Newcastle 1998. Lit.: V. Button, *The Turner Prize,* 1997.

Tracey Emin **74**
b. London 1963. Maidstone CA 1986–8; RCA 1987–9. Recent solo exh.: South London Gallery 1997; Igesellschaft für Aktuelle Kunst, Bremen 1998; Sagacho Exhibition Space, Tokyo 1998. Contrib. to group exh. since 1993, incl. *Brilliant!* 1995; *Sensation* 1997; *Art from the UK: Angela Bulloch, Willie Doherty, Tracey Emin, Sarah Lucas, Sam Taylor-Wood,* Sammlung Goetz, Munich 1998. Lit.: N. Brown et al., *Tracey Emin,* 1998.

Ian Hamilton Finlay **68**
b. Nassau, Bahamas 1925. Glasgow SA 1942–5. Recent solo exh.: Philadelphia Museum of Art 1991; Leeds City Art Gallery 1992; Joan Miró Foundation, Barcelona 1999. Selected group exh.: *Rhetorical Image,* New Museum of Contemporary Art, NY 1991; *Konfrontation,* Museum Moderner Kunst, Vienna 1993; La Biennale de Montreal, Centre International d'Art Contemporain de Montreal 1998. Lit: Y. Abrioux, *Ian Hamilton Finlay: A Visual Primer,*1985.

Barry Flanagan **121**
b. Prestatyn 1941. Birmingham CA 1957–8; St Martins SA 1964–6. Lives and works in Dublin. Recent solo exh.: Fundación 'la Caixa', Madrid 1993 (touring); Waddington Galleries 1994 (touring); Waddington Galleries / The Economist Plaza 1998. Contrib. to group exh. since 1965, incl.: *When Attitude Becomes Form,* Kunsthalle, Bern 1969 (touring); *The Quiet Revolution: British Sculpture since 1965,* MOCA, Chicago 1987 (touring); *Un siècle de sculpture anglaise* 1996. Lit.: *Barry Flanagan,* exh. cat., Fundación 'la Caixa', Madrid 1993.

Ceal Floyer **18**
b. Karachi 1968. Goldsmiths College 1991–4. Recent solo exh.: Lisson Gallery 1997; Galleria Primo Piano, Rome 1997; Künstlerhaus Bethanien, Berlin 1998. Contrib. to group exh. since 1992, incl.: *Fast Forward,* ICA 1994; *Pictura Britannica,* MOCA, Sydney 1997; *Material Culture* 1997. Lit.: *The British Art Show 4,* exh. cat., South Bank Centre 1996.

Lesley Foxcroft **115**
b. Sheffield. Camberwell SA 1970–4. Lives and works in St Albans. Recent solo exh.: Haus (Max) Bill, Zurnikon nr Zurich 1997; Cairn Gallery, Gloucestershire 1998; Laure Genillard Gallery 1998. Contrib. to group exh. incl.: *A Sense of Purpose,* Mappin Art Gallery, Sheffield 1992; *Immerzeit,* ACP Gallery, Zurich 1996; *Synligt: England,* Sverige, Konstruktiv Tendens, Stockholm 1998. Lit.: *Lesley Foxcroft* (artist's book) 1994.

Bill Furlong **101**
b. Woking 1944. Guildford SA 1960–5; RA Schools 1965–8. Recent solo exh.: Kunstverein, Bregenz 1998; *Sound Garden,* commissioned by Serpentine Gallery 1998; Imperial War Museum 1998. Contrib. to group exh. since 1967, incl.: *Life/Live: New Manifestations in British Art,* Musée d'art moderne de la ville de Paris 1997; *Voice Over,* Arnolfini, Bristol 1998; *Kunst in der Stadt 2,* Kunstverein, Bregenz 1998. Lit.: M. Archer, *Audio Arts: Discourse and Practice in Contemporary Art,* 1994.

Anya Gallaccio **104**
b. Paisley 1963. Kingston Polytechnic 1984–5; Goldsmiths College 1985–8. Recent solo exh: Serpentine Gallery 1997; Delfina Studios 1998; Tramway, Glasgow 1999. Contrib. to group exh. since 1988, incl.: *Brilliant!* 1995; *Real Life: New British Art,* British Council touring exh., Japan 1998; *Artranspennine98,* 1998. Lit.: *Chasing Rainbows,* exh. cat., Tramway / Locus+, Glasgow 1999.

John Gibbons **30**
b. Ennis, County Clare 1949. Limerick SA 1969–70, Crawford Municipal SA, Cork 1970–2; St Martins SA 1972–6. Recent solo exh.: Whitworth Art Gallery, Manchester / Kettle's Yard, Cambridge 1997; Temple Bar Gallery, Dublin / Crawford Municipal Art Gallery, Cork 1998. Contrib. to group exh. since 1974, incl.: *Now for the Future,* Hayward Gallery 1990; *British Abstract Art, Pt 2, Sculpture,* Flowers East 1995; *Irish Steel,* Model Arts Centre, Sligo 1995 (touring). Lit.: *John Gibbons: Form and Content,* exh. cat., Whitworth Art Gallery, Manchester 1997.

Gilbert and George **103**
Gilbert Proesch: b. Dolomites, Italy 1943; St Martins SA 1967–70. George Pasmore: b. Devon 1942; St Martins SA 1967–70. Recent solo exh.: Sezon Museum, Tokyo 1997; Musée d'art moderne de la ville de Paris 1997; Museo di Capodimonte, Naples 1998. Contrib. to group exh. since 1969, incl.: *Forty Years of Modern Art,* Tate Gallery 1986; *Turner Prize,* Tate Gallery 1986; *British Art in the 20th Century,* RA 1987; *Visions Urbaines,* Musée national d'art moderne, Paris 1994. Lit.: *The Words of Gilbert & George with Portraits of the Artists from 1968 to 1997,* 1997.

Douglas Gordon **43**
b. Glasgow 1966. Glasgow SA 1984–8; Slade SA 1988–90. Lives and works in Glasgow. Recent solo exh.: Centre Georges Pompidou, Paris 1995; Biennale de Lyon 1997; Kunstverein Hannover 1998. Contrib. to group exh. since 1989, incl.: *The British Art Show 4* 1995 (touring); *Turner Prize,* Tate Gallery 1996; *Material Culture* 1997; *Projected Allegories,* Contemporary Arts Museum, Houston, Texas 1998. Lit.: *Kidnapping: Douglas Gordon,* exh. cat., Stedelijk Van Abbemuseum, Eindhoven 1998.

Frederick Gore **37**
b. Richmond, Surrey 1913. Westminster SA 1934–7; Slade SA 1937. Recent solo exh. incl.: RA 1989; The Gallery at John Jones 1993; Fosse Gallery 1996, 1999. Group exh. incl.: *Contemporary Art Society Exhibition,* Tate Gallery 1954, 1956, 1958; *Jubilee Exhibition of British Painting 1952-77,* RA 1977. Lit.: *The Dictionary of Artists in Britain since 1945,* Bristol 1998, p.49.

Antony Gormley 27
b. London 1950. Central SA 1974–5; Goldsmiths College 1975–7; Slade SA 1977–9. Recent solo exh.: Kunstverein, Cologne 1997; RA 1998; Xavier Hufkens, Brussels 1999. Selected group exh. incl.: *British Sculpture in the 20th Century,* Whitechapel Art Gallery 1981; *Turner Prize,* Tate Gallery 1994; *Un siècle de sculpture anglaise* 1996; *The Mass Ornament,* Kunsthallen Brandts Klaedefabrik, Odense 1998. Lit.: E.H. Gombrich et al., *Anthony Gormley,* 1995.

Mona Hatoum 79
b. Beirut, Lebanon 1952. Byam Shaw SA 1975–9; Slade SA 1979–81. Recent solo exh.: MOCA, Chicago 1997; Scottish National Gallery of Modern Art, Edinburgh 1998; Castello di Rivoli, Turin 1999. Contrib. to group exh. since 1987, incl.: *Sense and Sensibility: Women and Minimalism in the Nineties,* MOMA, NY 1994; *Identity and Alterity,* Venice Biennal 1995; *Turner Prize,* Tate Gallery 1995; *Wounds: Between Democracy and Redemption in Contemporary Art,* Moderna Museet, Stockholm 1998. Lit.: M. Archer et al., *Mona Hatoum,* 1997.

Susan Hiller 118
b. Carson City, Nevada 1940. Smiths College, MA 1961–5; Tulane University, New Orleans 1965. Recent solo exh.: Tate Gallery Liverpool 1996; Institute of Contemporary Art, Philadelphia 1998; Henie Onstad Kunstsenter, Oslo 1999. Contrib. to group exh. since 1973, incl.: *Material Culture* 1997; *Out of Actions: Between Performance and the Object,* MOCA, Los Angeles 1998; *The Muse in the Museum,* MOMA, NY 1999. Lit.: *Susan Hiller,* exh. cat., Tate Gallery Liverpool 1996.

John Hilliard 41
b. Lancaster 1945. Lancaster CA 1962–4; St Martins SA 1964–7. Recent solo exh.: Kunsthalle Krems 1997; Kunstverein Hannover 1997; Galerie Durand-Dessert, Paris 1997. Contrib. to group exh. since 1971, incl.: *Through the Looking Glass,* Barbican Art Gallery 1989; *Prospect 96,* Kunstverein, Frankfurt 1996; *The Magic of Numbers,* Staatsgalerie, Stuttgart 1997. Lit.: *John Hilliard: Works 1990–96,* exh. cat., Kunsthalle Krems 1997.

Damien Hirst 33
b. Bristol 1965. Goldsmiths College 1986–9. Recent solo exh.: Dallas Museum, Texas 1994; Gagosian Gallery, NY 1996; Bruno Bischofberger, Zurich 1997. Contrib. to group exh. since 1988, incl.: *Freeze,* London Docklands 1988; *Some Went Mad, Some Ran Away,* Serpentine Gallery 1994 (touring); *Brilliant!* 1995; *Sensation* 1997. Lit.: G. Burn and S. Morgan, *I Want To Spend The Rest of My Life Everywhere, With Everyone, One to One, Always, Forever, Now,* 1997.

David Hockney 77
b. Bradford 1937. Bradford SA 1953–7; RCA 1959–62. Lives and works in Los Angeles. Recent solo exh.: Manchester City Art Galleries 1996; Annely Juda Fine Art 1997; Centre Georges Pompidou, Paris 1999. Retrospective exh: Whitechapel Art Gallery 1970 (touring); Los Angeles County Museum of Art 1988 (touring). Lit.: M. Livingstone, *David Hockney,* enlarged ed., 1996.

Howard Hodgkin 107
b. London 1932. Camberwell SA 1949–50; Bath Academy of Art 1950–4. Recent solo exh.: British Pavilion, Venice Biennale 1984; Modern Art Museum of Fort Worth, Texas 1995 (touring); Gagosian Gallery, NY 1998. Contrib. to group exh. since 1959, incl.: *John Moores' Liverpool Exhibition 10/12,* Walker Art Gallery, Liverpool 1976/80; *Portrait of the Artist,* Anthony d'Offay Gallery 1996. Lit.: A. Graham-Dixon, *Howard Hodgkin,* 1994.

Shirazeh Houshiary 29
b. Shiraz, Iran 1955. Chelsea SA 1976–9; Cardiff CA 1979–80. Recent solo exh.: Lisson Gallery 1994; Le Magasin, Centre national d'art contemporain, Grenoble 1995 (touring); British Museum 1997. Contrib. to group exh. since 1982, incl.: *Machines for Peace,* Venice Biennale 1993; *Turner Prize,* Tate Gallery 1994; *Negotiating Rapture,* MOCA, Chicago 1996; Goodwood Sculpture Park 1997. Lit.: *Shirazeh Houshiary,* exh. cat., Centre d'art contemporain, Geneva / MOMA, Oxford 1988.

John Hoyland 92
b. Sheffield 1934. Sheffield CA 1951–4; RA Schools 1956–60; Central SA 1958. Recent solo exh.: CCA Galleries 1994; Curwen Gallery 1994; Footstool Gallery 1997. Group exh. incl: *British Art in the 20th Century,* RA 1987; *New Realists: Art from Post War Europe 1945–68,* Tate Gallery Liverpool 1993; *Here and Now* 1995. Lit.: M. Gooding and J. Taylor, *John Hoyland,* 1990.

Gary Hume 87
b. Kent 1962. Goldsmiths College 1985–8. Recent solo exh.: Kunsthalle, Bern 1995; Bonnefantenmuseum, Maastricht 1996, Venice Biennale 1999. Contrib. to group exh. since 1988, incl.: *Turner Prize* 1996; *Sensation* 1997; *Jerwood Painting Prize 1997,* Lethaby Galleries, Central St Martins College of Art and Design 1997. Lit.: *Gary Hume Paintings,* exh. cat., Kunsthalle, Bern / ICA, London 1995.

Callum Innes 81
b. Edinburgh 1962. Grays SA, Aberdeen 1980–4; Edinburgh CA 1984–5. Lives and works in Edinburgh. Recent solo exh.: ICA 1992; Jan Turner Gallery, Los Angeles 1993; Ikon Gallery, Birmingham 1998 (touring). Contrib. to group exh. since 1989, incl.: *The British Art Show,* London and Glasgow 1990; *Turner Prize* 1995; *Abstractions Provisoires,* Musée d'art moderne de St Etienne 1997; *1998 Nat West Art Prize,* Lothbury Gallery (1st Prize) 1998. Lit.: *Callum Innes,* exh. cat., Ikon Gallery, Birmingham / Kunsthalle Bern 1998.

Alan Johnston 105
b. Edinburgh 1945. Edinburgh CA 1964–9; RCA 1970–2. Lives and works in Edinburgh. Recent solo exh.: Lisson Gallery 1996; Gallery Gangurinn, Reykjavik 1997; Jack Tilton Gallery, NY 1998. Contrib. to group exh. since 1973, incl.: *Skulpturen Republik*, Kunstraum Wien im Messepalast, Vienna 1988; *A Passion for Painting*, Whitney Museum, NY 1997; *Ground*, Galerie Stadtpark, Krems an der Donau 1998. Lit.: *Alan Johnston: Haus Wittgenstein-Inverleith House*, exh. cat., Royal Botanic Garden, Edinburgh 1999.

Allen Jones 23
b. Southampton 1937. Hornsey CA 1955–9, 1960–1; RCA 1959–60. Recent solo exh.: Barbican Art Gallery 1995; Galeria Civica, Modena 1996; Trussardi, Milan 1998. Contrib. to group exh. since 1960, incl.: Dokumenta IV, Kassel 1968; *British Art in the 20th Century*, RA 1987; *Pop Art*, RA 1991. Lit.: M. Livingstone, *Allen Jones: Prints*, 1995.

Peter Joseph 60
b. London 1929. Lives and works in Gloucestershire. Recent solo exh.: MOMA, Oxford 1994; Galerie Meert Rihoux, Brussels 1996; Lisson Gallery 1998. Contrib. to group exh. since 1964, incl.: *Ready, Steady, Go: Paintings of the Sixties from the Arts Council Collection,* Royal Festival Hall 1992; *Les Bords de l'oeuvre,* Musée Matisse, Nice 1995; *Formes du simple, exercices d'associations,* MAMCO, Geneva 1997. Lit.: *Peter Joseph,* exh. cat., Kent Fine Art, NY 1987.

Anish Kapoor 28
b. Bombay 1954. Hornsey CA 1973–7; Chelsea SA 1977–8. Recent solo exh.: Tel Aviv Museum of Art 1993; Kunst-Station Sankt Peter, Cologne 1996; Hayward Gallery 1998. Contrib. to group exh. since 1974, incl.: *Un siècle de sculpture anglaise* 1996; *Changing Spaces,* Detroit Institute of Arts 1997; *Towards Sculpture,* Calouste Gulbenkian Foundation, Lisbon 1998. Lit.: *Anish Kapoor,* exh. cat., San Diego MOCA 1992.

Phillip King 61
b. Kheredine, nr Carthage, Tunisia 1934. St Martins SA 1957–8. Lives and works in London and Kent. Recent solo exh.: Galerie Waszkowiak/ Walter Bischoff Galerie, Berlin 1995; Yorkshire Sculpture Park, Wakefield 1996; Forte di Belvedere, Florence 1997. Group exh. incl. *British Art in the 20th Century*, RA 1987; Venice Biennale 1988; *Un siècle de sculpture anglaise* 1996. Lit.: *Phillip King*, exh. cat., Forte di Belvedere, Florence 1997.

Langlands and Bell 19
Ben Langlands: b. London 1955. Middlesex Polytechnic 1977–80. Nikki Bell: b. London 1959. Middlesex Polytechnic 1977–80. Recent solo exh.: Serpentine Gallery 1996; CCA Kitakyushu 1997; TN Probe, Tokyo 1998. Contrib. to group exh. since 1980, incl.: *Architecture as Metaphor*, MOMA, NY 1997; *Futuro, Presento, Pasato 1967–1997*, Venice Biennale 1997; *Sensation* 1997. Lit.: *Langlands & Bell*, exh. cat., Serpentine Gallery 1996.

Sarah Lucas 86
b. London 1962. Working Men's College 1982–3, London College of Printmaking 1983–4; Goldsmiths College 1984–7. Recent solo exh.: Museum Boymans-van Beuningen, Rotterdam 1996; St Johns Lofts 1997; Ludwig Museum, Cologne 1997. Contrib. to group exh. since 1986, incl: *Freeze*, London Docklands 1988; *Brilliant!* 1995; *Sensation* 1997. Lit.: *Sarah Lucas,* exh. cat., Museum Boymans-van Beuningen, Rotterdam 1996.

Bruce McLean 44
b. Glasgow 1944. Glasgow SA 1961–3; St Martins SA 1963–6. Recent solo exh.: Scottish Gallery, Edinburgh 1992; Cornerhouse, Manchester 1995 (touring); Galerie se, Bergen 1997; Galerie Fortlaan 17, Ghent 1998. Contrib. to group exh. since 1965, incl.: *British Sculpture in the 20th Century*, Whitechapel Art Gallery 1981; *British Art in the 20th Century,* RA 1987; *Out of Action; Between Performance and the Object, 1949–79*, MOCA, Los Angeles 1997. Lit.: M. Gooding, *Bruce McLean,* Oxford / NY 1990.

Lisa Milroy 38
b. Vancouver 1959. St Martins SA 1977–9; Goldsmiths College 1979–82. Lives and works in London. Recent solo exh.: Chisenhale Gallery 1995 (touring); Galerie Jennifer Flay, Paris 1996; Waddington Galleries 1998. Contrib. to group exh. since 1983, incl.: *British Art Now: A Subjective View,* Setagaya Art Museum, Tokyo 1990 (touring); *Carnegie International 1991,* Pittsburgh, Pennsylvania 1991; *Der zerbrochene Spiegel/The Broken Mirror,* Museumsquartier Messepalast / Kunsthalle Wien, Vienna 1992 (touring). Lit *'Patience', Lisa Milroy: Paintings,* exh. cat., Waddington Galleries 1998.

David Nash 34
b. Esher 1945. Kingston CA 1963–7. Lives and works in Blaenau Ffestiniog. Recent solo exh.: Annely Juda Fine Art 1996; LA Louver, Los Angeles 1997; Galerie Lelong, NY 1998. Contrib. to group exh. since 1970, incl: *Here and Now* 1995; *A Sculptor's Choice: Works Selected by Ann Christopher R.A.,* RA 1996; *50 Years of British Sculpture*, Lothbury Gallery 1998. Lit.: J. Andrews, *The Sculpture of David Nash*, 1996.

Chris Ofili 52
b. Manchester 1968. Chelsea SA 1988–91; RCA 1991–3. Recent solo exh.: Contemporary Fine Art, Berlin 1997; Southampton City Art Gallery / Serpentine Gallery 1998; Whitworth Art Gallery, Manchester 1998. Contrib. to group exh. since 1989, incl.: *Whitworth Young Contemporaries,* Whitworth Art Gallery, Manchester 1989, 1990, 1991; *Brilliant!* 1995; *Sensation* 1997; *Turner* Prize, Tate Gallery 1998. Lit.: *Chris Ofili,* exh. cat., Southampton City Art Gallery / Serpentine Gallery 1998.

Julian Opie **95**
b. London 1958. Goldsmiths College 1979–82. Recent solo exh.:
Hayward Gallery 1993; Kunstverein Hannover 1994; Lisson Gallery
1996; Barbara Thumm Gallery, Berlin 1997. Contrib. to group exh. since
1982, incl.: *Objects for the Ideal Home: The Legacy of Pop Art,* Serpentine
Gallery 1991; *Machines for Peace,* Venice Biennale 1993; *Material Culture*
1997. Lit.: *Julian Opie,* exh. cat., South Bank Centre 1993.

Eduardo Paolozzi **57**
b. Leith 1924. Edinburgh CA 1943; Slade SA 1944–7. Recent solo exh.:
Yorkshire Sculpture Park, Wakefield 1994; Jason & Rhodes 1996;
European Patent Office, Munich 1996. Group exh. incl.: *British Sculpture
in the 20th Century,* Whitechapel Art Gallery 1981; *British Art in the 20th
Century,* RA 1987; *Un siècle de sculpture anglaise* 1996. Lit.: *Eduardo
Paolozzi: Mythologies: A Retrospective Survey 1946–90,* exh. cat., The
Scottish Gallery 1990.

Cornelia Parker **108**
b. Cheshire 1956. Wolverhampton Polytechnic 1975–8; Reading
University 1980–2. Recent solo exh.: ArtPace, San Antonio, Texas 1997;
Serpentine Gallery 1998; Deitch Projects, NY 1998. Contrib. to group
exh. since 1979, incl.: XXII Bienal de São Paulo 1994; *Turner Prize,* Tate
Gallery 1997; 1st Melbourne Bienale 1999. Lit.: *Cornelia Parker: Avoided
Object,* exh. cat., Chapter Arts Centre 1996, reprinted 1998.

Simon Patterson **63**
b. Leatherhead 1967. Goldsmiths College 1986–9. Recent solo exh.:
Lisson Gallery 1996; MOCA, Chicago 1997; Kohji Ogura Gallery,
Nagoya 1998. Contrib. to group exh. since 1988, incl.: *Freeze*
(Pts 1 & 3), London Docklands 1988; *Turner Prize,* Tate Gallery 1996; *The
Magic of Numbers,* Staatsgalerie Stuttgart 1997; Sydney Biennal 1997
(touring). Lit.: V. Button, *The Turner Prize,* 1997.

Marc Quinn **31**
b. London 1964. Cambridge University 1982–5. Recent solo exh.: South
London Gallery 1998; Gagosian Gallery, NY 1998; Kunstverein
Hannover 1999. Contrib. to group exh. since 1992, incl.: *Thinking Print:
Books to Billboards 1980–95,* MOMA, NY 1996; *Follow Me,* Kunstverein
Kehdingen, Freiburg 1997; *Sensation* 1997. Lit.: M. Gisbourne et al.,
Incarnate, London / NY 1998.

Fiona Rae **51**
b. Hong Kong 1963. Croydon CA 1983–4; Goldsmiths College 1984–7.
Recent solo exh.: ICA 1993; Saatchi Gallery 1997; Luhring Augustine,
NY 1997. Contrib. to group exh. since 1988, incl.: *Aperto,* Venice
Biennale 1990; *Turner Prize,* Tate Gallery 1991; *Nuevas Abstracciones,*
Palacio de Velázquez, Museo Nacional Centro de Arte Reina Sofia,
Madrid 1996 (touring); *Sensation* 1997. Lit.: *Between Control and
Abandon: Fiona Rae,* exh. cat., Kohji Ogura Gallery, Nagoya 1999.

Paula Rego **111**
b. Lisbon 1935. Slade SA 1952–6. Recent solo exh.: Tate Gallery
Liverpool 1997; Dulwich Picture Gallery 1998; Marlborough Gallery,
Madrid 1999. Contrib. to group exh. since 1955, incl.: *An American
Passion: The Summer Collection of Contemporary British Painting,* McLellan
Galleries, Glasgow 1994 (touring); *Spellbound: Art and Film,* Hayward
Gallery 1996; *The School of London,* Musée Maillol, Paris 1998 (touring).
Lit.: J. McEwen, *Paula Rego* 1992, new ed.1996.

Bridget Riley **71**
b. London 1931. Goldsmiths College 1949–51; RCA 1952–5. Recent
solo exh.: Waddington and Karsten Schubert Galleries 1996; Serpentine
Gallery 1999; Kunstverein für die Rheinlande und Westfalen, Düsseldorf
1999. Contrib. to group exh. since 1964, incl.: *The Responsive Eye,*
MOMA, NY 1965; British Pavilion, Venice Biennial 1968; *From Here,*
Karsten Schubert and Waddington Galleries 1995. Lit.: *The Mind's Eye:
Bridget Riley (Collected Writings 1965–1991),* ed. Robert Kudielka, 1999.

Georgina Starr **39**
b. Leeds 1968. Middlesex Polytechnic 1987–9; Slade SA 1990–2;
Rijksakademie van Beeldende Kunst, Amsterdam 1993–4. Recent solo
exh.: Tate Gallery 1996; Barbara Gladstone Gallery, NY 1996; Ikon
Gallery, Birmingham 1998. Contrib. to group exh. since 1990, incl.:
Brilliant! 1995; *Pictura Britannica,* MOCA, Sydney 1997 (touring); *Visions
of the Body: Fashion or Invisible Corset,* National Museum of Modern Art,
Kyoto /MOCA, Tokyo 1999. Lit.: *Georgina Starr,* exh. cat., Ikon Gallery
Birmingham 1998.

Sam Taylor-Wood **69**
b. London 1967. Goldsmiths College 1988–90. Recent solo exh.: Sala
Montcada de la Fundacion 'la Caixa', Barcelona 1997; Kunsthalle,
Zurich 1997 (touring); Prada Foundation, Milan 1998. Contrib. to group
exh. since 1991, incl. *Sensation* 1997; *Turner Prize,* Tate Gallery 1998;
Emotion: Young British and American Art from the Goetz Collection,
Deichtorhallen, Hamburg 1998. Lit.: *Sam Taylor-Wood,* exh. cat., Prada
Foundation, Milan 1998.

David Tremlett **70**
b. St Austell 1945. Falmouth CA 1963–6; Lives and works in
Bovingdon, Herts. Recent solo exh.: Carré D'Art, Nîmes, France 1995;
Gemeentemuseum, The Hague 1995; Joan Miró Foundation, Barcelona
1996. Contrib. to group exh. since 1970, incl. *Documenta 5,* Kassel
1972; *Turner Prize,* Tate Gallery 1992; *Wall to Wall,* Leeds 1994; *Au fil du
trait,* Carré D'Art, Nîmes 1998. Lit.: R. Dorment, 'David Tremlett',
Telegraph Magazine, 27 May 1995.

Gavin Turk 38

b. Guildford 1967. Chelsea SA 1986–9; RCA 1989–91. Recent solo exh.: Jay Jopling Gallery 1993; Aurel Schiebler, Cologne 1995; South London Gallery 1998. Contrib. to group exh. since 1991, incl.: *Young British Artists III*, Saatchi Collection 1995; *Material Culture* 1997; *Sensation* 1997. Lit.: A. Farquharson and J. Compston, *Gavin Turk: Collected Works 1994–98*, 1998.

Mark Wallinger 47

b. Chigwell 1959. Chelsea SA 1978–81; Goldsmiths College 1983–5. Recent solo exh.: Serpentine Gallery 1995; Palais des Beaux-Arts, Brussels 1999; Portikus, Frankfurt 1999. Contrib. to group exh. since 1981, incl.: *Turner Prize* 1995; *Sensation* 1997; 2nd Johannesburg Biennale 1997; *Wounds*, Moderna Museet, Stockholm 1998. Lit.: exh. cat., Palais des Beaux-Arts, Brussels 1999.

Gillian Wearing 58

b. Birmingham 1963. Chelsea SA 1985–7; Goldsmiths College 1987–90. Recent solo exh.: Gallery Koyanagi, Tokyo 1998; Centre d'art contemporain, Geneva 1998; Interim Art 1999. Contrib. to group exh. since 1991, incl.: *Brilliant!* 1995; *Sensation* 1997; *Turner Prize*, Tate Gallery 1997. Lit.: R. Ferguson et al., *Gillian Wearing*, 1999.

Richard Wentworth 21

b. Samoa 1947. Hornsey SA 1965–6; RCA 1966–70. Recent solo exh.: Christ Church Picture Gallery, Oxford 1996; Kunstverein Freiburg 1997 (touring); Kettle's Yard, Cambridge 1998. Contrib. to group exh. since 1969, incl.: *Objects for the Ideal Home: The Legacy of Pop Art,* Serpentine Gallery 1991; *Here and Now* 1995; *Material Culture* 1997. Lit.: *Here and Now*, exh. cat., Serpentine Gallery 1995.

Karl Weshke 117

b. Taubenpreskeln, nr Gera, Germany 1925. Lives and works in Cape Cornwall. Recent solo exh.: Redfern Gallery 1994; extended display, Tate Gallery 1996; extended display, Tate Gallery St Ives 1996. Contrib. to group exh. since 1957, incl.: *The British Art Show: Recent Paintings and Sculpture by 112 Artists*, Arts Council of Great Britain touring exh. 1979; *St Ives 1939–64: Twenty Five Years of Painting, Sculpture and Pottery*, Tate Gallery 1985; *Jerwood Painting Prize*, Royal Scottish Academy, Edinburgh and RA 1995. Lit.: J. Lewison, *Karl Weschke: Portrait of a Painter*, 1998.

Anthony Whishaw 123

b. London 1930. Chelsea SA 1948–52. Recent solo exh.: Barbican Art Gallery 1994 (touring); Art Space Gallery 1995; Art First 1997. Contrib. to group exh. since 1957, incl.: *Hayward Annual*, Hayward Gallery 1980; *European Art Today*, Spuren und Zeiichen, Trier 1984; *Romantic Tradition in Contemporary British Painting*, touring Spain 1988. Lit.: *Anthony Whishaw: Images of Ideas with Memory in Mind: New Paintings*, exh. cat., Art First 1997.

Rachel Whiteread 40

b. London 1963. Brighton Polytechnic 1982–5; Slade SA 1985–7. Recent solo exh.: Tate Gallery Liverpool 1996 / Reina Sofia, Madrid 1997; British Pavillion, Venice 47th Biennale of Art 1997; Public Art Fund, NY 1998. Contrib. to group exh. since 1987, incl.: *Turner Prize*, Tate Gallery 1991, 1993; *Here and Now* 1995; *Sensation* 1997; *Wounds*, Moderna Museet, Stockholm 1998. Lit.: *Shedding Life,* exh. cat., Tate Gallery Liverpool 1996.

Alison Wilding 114

b. Blackburn 1948. Ravensbourne CA, Bromley 1967–70; RCA 1970–3. Recent solo exh.: Karsten Schubert 1995; Musée des Beaux-Arts et de la Dentelle de Calais 1996; Abbot Hall Art Gallery, Kendal 1997. Group exh. incl.: *In Site: New British Sculpture*, National Museum of Contemporary Art, Oslo 1993; *Here and Now* 1995; *Material Culture* 1997. Lit.: H. Gresty, *Alison Wilding: Bare*, Newlyn Art Gallery, Penzance 1993.

Richard Wilson 113

b. London 1953. Hornsey CA 1971–4; Reading University 1974–6. Recent solo exh.: Matt's Gallery 1994; LA/UK Festival, MOCA, Los Angeles 1994; Serpentine Gallery 1996. Contrib. to group exh. since 1975, incl.: Sydney Biennale 1992; *Mirades (sobre el Museu),* Museu D'Art Contemporani, Barcelona 1996; *Islands,* National Gallery of Australia, Canberra 1996. Lit.: *Jamming Gears*, exh. cat., Serpentine Gallery 1996.

Bill Woodrow 24

b. Henley 1948. Winchester SA 1967–8; St Martins SA 1968–71; Chelsea SA 1971–2. Recent solo exh.: Model Arts Centre, Sligo / Limerick City Gallery of Art 1994; Camden Arts Centre 1995; Tate Gallery 1996. Group exh. incl.: *British Sculpture since 1965*, MOCA and Peace Museum, Chicago 1987 (touring); *Sculpture at Goodwood,* Goodwood Sculpture Park 1994; *Contemporary British Art in Print,* Scottish National Gallery of Modern Art, Edinburgh (touring). Lit.: *Fools' Gold,* exh. cat., Tate Gallery 1996.

I would like to thank every artist I have worked with, whether they are in the book or not,
for their time and their understanding of the project.
I would also like to thank:

at Tate Gallery Publishing:
Celia Clear, Delphine Cool, Frances Croxford, Mark Eastment, Tim Holton, Susan Lawrie, Judith Severne

at the Tate Gallery:
Kate Burvill, Virginia Button, Tiffany Vignoles

at the British Council (England):
Caroline Douglas, Anne Gallagher, Brett Rogers, Andrea Rose, Tansyn Woolcombe

at the British Council (France):
Catherine Ferbos

Julia Royse at White Cube
Lorcan O'Neil and Robin Vousden at Anthony d'Offay Gallery
Ian Thomson at Annely Juda Fine Art
Geoffrey Parton at Marlborough Fine Art Gallery
Susan Waxman at the Lisson Gallery
Laure Genillard

Will Alsop
David Buckland and Siobhan Davies
Corporart
Tara and Flan Flanagan
Rhiannon Gooding
The Independent Saturday Magazine
Leslie and John MacDonald
Sam Mundy

Glen Brent for printing the photographs.

Richard Krzyzak for his friendship and wonderful design.

A special thanks to Mel Gooding for his total commitment to the project: his help has been very precious.

And to Benedicte for her patience and complete support, the book would have been difficult to finish without her.